PORTLAND
PUBLIC
SCULPTORS

PORTLAND PUBLIC SCULPTORS

MONUMENTS, MEMORIALS AND STATUARY

1900–2003

FRED F. POYNER IV

AMERICA
THROUGH TIME®
ADDING COLOR TO AMERICAN HISTORY

For Annie and Gavin

America Through Time is an imprint of Fonthill Media LLC
www.through-time.com
office@through-time.com

Published by Arcadia Publishing by arrangement with Fonthill Media LLC
For all general information, please contact Arcadia Publishing:
Telephone: 843-853-2070
Fax: 843-853-0044
E-mail: sales@arcadiapublishing.com
For customer service and orders:
Toll-Free 1-888-313-2665

www.arcadiapublishing.com

First published 2021

ISBN 978-1-63499-307-4

Typeset in 10pt on 12pt Sabon
Printed and bound in England

FOREWORD

My memories of the sculptor George Fite Waters have all come from my grandmother, Helen Greenwell Waters, as sadly I was just a baby when he passed away. Always known to us as "The Grandfather," you might imagine how this conjured up an image of a distant, cold, and formal man for me. However, this was not the case.

Grandfather was indeed a "free spirit," driven by a great passion for the arts. As a young man of modest means, he left San Francisco and set off for Paris to study under Rodin and met my grandmother, a well-to-do, spunky, and rebellious English socialite. They fell in love and were married. Grandfather told her if she desired to have a wedding ring, she would simply have to take care of that herself (she did just that).

The mid-1920s was an uncertain time with the Great Depression and World War II looming on the horizon. It was through Grandfather's U.S. citizenship that he made it possible for my grandmother and my father (age ten) to escape Europe via a harrowing journey over the Pyrenees, securing passage on a blacked-out ship across the Atlantic to the U.S. They were reunited with Grandfather and settled permanently in Wilton, Connecticut.

I have fond memories of *The President* model that resided on a pedestal in a quiet corner of my grandparent's sitting room: this figure of Lincoln always seemed to be gazing down on us while we played with our toys. We grew up surrounded by various pieces of sculpture and art scattered through the tiny home and consequently developed a love for the arts of our own—their fondest wish. The small studio building where he worked, affectionately named the "Little House," still stands today on the property where my older brother resides with his family. Today, the model of Lincoln from my childhood has a place of honor in my own home in Texas.

I am most grateful to Fred Poyner IV for his impressive work and giving this wonderful story extended life especially in a time where commemoration of history appears to be quite fragile.

Joyce Waters Ratliff

ACKNOWLEDGMENTS

It is always a boon when an art historian is able to consult with primary sources about art and sculpture. For their assistance with the research of the book, I am grateful to Joyce Waters Ratliff and Tanya Bull for their sharing of materials from the sculptors George Fite Waters and Count Alexander von Svoboda, respectively. Several of the images included have never before been shared with the public. As relatives of these sculptors, their assistance with these family collections has been invaluable.

In a similar fashion, I have to personally thank the sculptors Raymond Kaskey and James Lee Hansen for taking the time to speak with me about their Portland sculptures and share details about these efforts. Jane Hansen offered great feedback on the scope of her husband's life work and its context as part of the city of Portland's landscape today. Her patience with my many questions was much appreciated.

Several other key collections and archives were instrumental in the search for details about the lives and artistic careers of the sculptors. These included: City of Portland Archives and Records Center; Buffalo Bill Center of the West; The University Archives and Records Center, University of Pennsylvania; Oregon Historical Society; and the University of Oregon Libraries.

Several people were instrumental in offering read-throughs of the early drafts, which was a great help in improving the narrative overall. In particular, I would like to thank Gwen Whiting with the Washington State Historical Society for her many great comments and insights; Tessa Campbell at the Hibulb Cultural Center, Tulalip Tribes; David Bader for his review of *The Ideal Scout*; and Jonathan Sajda for his timely and candid input on war memorials. My gratitude and appreciation extend as well to both Kena Longabaugh and Alan Sutton at Fonthill for their support of the publication of the new book as part of the *America Through Time* series.

The images included in the book are an important mix of both historical views and contemporary photos of public sculpture in Portland. The saying "many hands make light work" holds true here for the research and collections access assistance provided. The following individuals and organizations have made helpful and timely contributions to the book with images and archives: Mary Hansen at the City of Portland Archives

and Records Center; Robert Warren and Oregon Historical Society (OHS); Brian Libby; J. Scott Collard; John Terry, Ryan Fernandez, and *The Oregonian*; Julia Simic and Lauren Goss with University of Oregon Libraries; Sylvia Huber and the Whitney Western Art Museum; Jeremy Dimick at the Detroit Historical Society; Nancy McClure and Mack Frost with the Buffalo Bill Center of the West; Emma Pletz and Oregon State Elks Association; Columbia Pacific Council of the BSA, Portland; Becky Norman with King County Library Service (KCLS); Paula Stoeke and Anna Healy with the Seward Johnson Atelier; sculptor Seward Johnson; Jonathan Smith at the Jordan Schnitzer Museum of Art; Judy Anderson; and Multnomah County Library.

For their support of the book, I would like to acknowledge Nicolette Bromberg, University of Washington Libraries; Jennifer Kilmer, Washington State Historical Society; and Dipali Desai at Bellevue College.

This book is a tribute to all the sculptors of Portland, Oregon, whose efforts have collectively enhanced the city's landscape over time.

CONTENTS

INTRODUCTION

Public statuary and other sculptures scattered across Portland's landscape make up an eclectic assortment of historical figures, allegorical themes, and artistic pieces of twentieth-century modern art styles and movements. It is much like many American cities today in this regard; these sculptures range from the merely decorative to idealized personifications of individuals, varying in realistic degrees depending on the sculptor and the times in which these artworks were created. The late nineteenth to early twentieth century was a time of great expansion for sculptors of all kinds and abilities throughout the United States, with its nationwide cornucopia of new buildings, settlements, streets, and public squares.

Some—not all, but some—also served as visual hallmarks to a functional structure or utilitarian purpose. Architectural details, such as those decorative motifs that adorned pediments and columns, entryways, and gates, provided sculpture as an integral part of a city's buildings and landscape. However, the identity of the sculptor was not considered important at the time.

Notably also in this category were public fountains, which were often accompanied by a centralized statue and other sculptural details around a fountain's base or the pedestal of the statue in the center. Portland was no different in its regard for incorporating public fountains into its squares, to serve as drinking stations for animals ranging from horses (a local transportation conveyance of choice in the late eighteenth century) to other animals such as dogs, oxen, and even livestock.

The fountains and their sculptural elements were a steady source of income for sculptors in the United States. As cities and towns grew with expansion on the West Coast, with new railroads, ports, and pioneer wagons bringing droves of settlers and business interests "out west," so too did the sculptors and their artistic brethren follow. Many came from Chicago and New York, where they already had established practices, public monuments, and sculptures to their credit, as well as studios with space and assistants, to create models and castings from new designs.

As one of these "new" West Coast cities, Portland was a natural location for new sculpture commissions to flourish. By the 1890s, it had grown to a respectable size as

one of Oregon's largest cities in terms of population and business capital as a port city strategically placed on the Columbia River and the border with Washington state. The venue was set, so to speak, and ripe for sculptors seeking to make their mark with new public artwork commissions.

This brings the equation around to its necessary third leg of support: in order for a public sculpture to progress from a mere idea or proposal, to become a concrete reality set in stone, bronze, or other media, it required a source of support or patronage interest to underwrite the effort. In this area, too, Portland had its new champions.

The scope of this book reviews a mix of sculptors and their Portland work, with two of them—Raymond Kaskey and James Lee Hansen—still alive and active as of this publication. The relatives of two others—Waters and Svoboda—were instrumental in the sharing of historical details, photographs, and insights about the lives of these sculptors and their Portland sculptures *The President* and *The Quest*, respectively.

The nature of public art and sculpture is changing in America. They are serving as "gathering places" for people calling for societal change in the new century. Some of these sculptures are themselves the focus for this collective consciousness about art and how it may represent both the worst and the best in us; others, like the *Elk* sculpture of Portland, have simply been caught in the crossfire of a public outpouring over the debate (sometimes literally heated) surrounding social justice issues. By looking back over the past century at Portland's sculptors, the hope is to learn about the history of these artworks to help us shape a constructive dialogue and better understanding of them as individual works and collectively, as we move forward together into the twenty-first century.

1

ROLAND HINTON PERRY
(1870–1941)

The public sculpture of Portland began in the late nineteenth century as a (mostly) privately-funded endeavor involving one patron, David P. Thompson, and his sculptor of choice, Roland Hinton Perry.

Thompson was both an idealist and a visionary, where public sculpture would play a role in his advocacy on behalf of the city. The process of selection was personalized, specific to his desire to see a new public fountain installed in downtown Portland. In his drive to see the artwork created, Thompson's motivations were practical in one sense—he wanted to ensure that local horses and other animals had a place to drink from, as this part of the city was indeed lacking in a water supply in this part of the city for that purpose. Horses were an everyday sight in Portland, used as a primary mode of transportation (the first automobiles not commonly used vehicles until the early 1900s). A member of the Oregon Humane Society, W. T. Shanahan, remarked how the need for animal drinking sources was still the case seven years after Thompson's call for a new fountain.

Thompson further based his rationale for adding a new fountain with an accompanying sculpture at its center, on the presence of another fountain already found in the city. The *Skidmore Fountain*, which is dated to 1888, had set a high bar in Thompson's view as a functionary piece, which had a large fountain pool with bronze figures on either side of a central column supporting a bronze fountain dish. The whole design was done in a Neoclassical style, from the robes and sandals worn by the figures, to the fluting motifs decorating the base of the fountain's bowl. Indeed, Thompson pointedly mentioned in his letter, that he could look outside his office window of the New Market Building and "see the great benefit The Skidmore Fountain is to Portland."[1] Olin Warner, the sculptor of the fountain's central bronze figures, received high praise many years later, when Lorado Taft remarked upon seeing it during a visit in 1934 how "There is no better sculpture in America than this … it is pure classic art, nothing showy about it, but it is a very beautiful thing."[2]

Thompson sought to see Warner's efforts recreated, with himself in the role of patron akin to the earlier fountain's patron and namesake, Stephen G. Skidmore.

His convictions on the subject were such that he wrote a letter in June 1899 to the city mayor citing the existing work as a model for a new fountain, which he personally would pay for to see installed between the Plaza Blocks of Lownsdale and Chapman Squares. The letter, which received wide circulation and was reprinted in *The Oregonian*, crystalized two main points for Thompson: first, that the city would benefit collectively from the addition of a new public watering/drinking source; and second, that the effort would rectify a lack of public investment by the citizenry, not seen since Skidmore's effort.

In this era of American idealism, which loosely followed the rise of the industrial age across the nation, prominent businessmen with influence and power, equipped with both funding and political connections, oftentimes held much sway over the urban communities they lived in. This influence extended to the arts, the selection of artists, and to another degree, both the style and subject of a particular artwork commission, like a fountain sculpture. These commissioned sculptures for public venues ranged from realistic and modeled after living subjects (e.g. portraiture pieces) to allegorical subjects and figures from Greek and Roman mythology. These works were done in a style that found widespread acceptance throughout the United States, from building façades and other architectural elements, to large-scale monuments, interior design, and décor.

As the principal patron for a new fountain, Thompson was not subject to any public art commission or review process, and as a patron of this age, his was a singular viewpoint in how such a new sculpture would come to pass.

Thompson's own history reflects many of the similar traits found in successful public art patrons of the time. He was a "self-made" man, having come out west from Ohio in 1853, penniless when he arrived in Oregon City at the age of nineteen, yet confident nonetheless in his prospects. He had a trailblazer mentality, which was geared towards achieving visible progress; as a surveyor, he helped lay the groundwork for new transportation infrastructure, by way of survey work for the first railroad into Oregon. Further work in land surveying in the 1860s established him as a local authority in legal matters of property ownership and development, both areas key to the continued growth of Portland as a city. Upon this labor, he expanded to financing, eventually becoming the president or director of seventeen banks throughout the Pacific Northwest. Thompson was ambitious, with political aspirations that led him to serve as a Republican in the Oregon Legislature for over thirty years. His political career was punctuated with peaks that included a governorship of Idaho Territory in 1876, followed by elections to two terms as the mayor of Portland in 1879 and 1881. His familiarity with the halls of power was, therefore, an asset in securing support for a project he deemed to be in the public's best interests.

There does remain the question of how important the notion of sculpture as an artwork played into Thompson's thought process. While the idea of a functional fountain as a new public fixture may have weighed more importantly in his planning and consideration, he clearly did have a direction intended for the artwork component from the beginning.

Thompson already envisioned the sculpture's choice of subject at the time he presented his support to the city publicly, when his letter to the city was published by *The Oregonian* in summer 1899. The sculpture he proposed would present the animal, the Roosevelt elk (otherwise called the Olympic elk); they were commonly known to have inhabited the region around Portland and Western Oregon. The location and placement of the fountain would serve not only as a strategic watering hole added for

the city's denizens and their animals, but it was also ostensibly done on a historical basis, as the Plaza Blocks area was reputed to have been a former feeding ground for elk that ranged in the west hills of the city.

Whether or not the choice was made to memorialize the Roosevelt elk (*Cervus canadensis roosevelti*) as a species is another question, one not answered by Thompson or expressed in his original motivations given voice. The use of sculpture to memorialize animals specifically had not found widespread usage by sculptors throughout the United States until this time, and what depictions there were could be applied to those beloved pets whose owners grieved and sought the solace of them rendered into stone or marble.

Thompson was equally vocal and selective in his choice of sculptor, as he was in the subject and placement of the new fountain sculpture. The city engineer had already been consulted as to the choice of the Plaza Blocks as the location, and true to his understanding of municipal processes, Thompson likewise invited the city council, board of public works, and water committee to all weigh in on his proposition.[3] His enlistment of Portland's official agencies and elected officials was strategic, and all but assured that Thompson's effort would receive full support.

As for the selection of the sculptor, there was no public call for design ideas or open competition among sculptors near and far. He desired the commission to be done by Roland Hinton Perry, a young New York sculptor whom Thompson characterized as accomplished in his "ability to model figures to dramatic effect."[4] The patron was even specific as to the completion date of the new fountain—on or before July 4, 1900.

Parry was indeed an interesting choice. He was certainly trained in the sculpture arts, and at the time he was approached by Thompson, he had already achieved at least two prominent city-installed sculptural works on the East Coast.

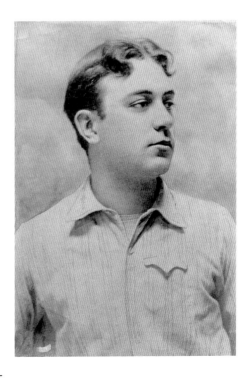

Roland Hinton Perry, *c.* 1909. (*Smithsonian Institution*)

Parry was trained in traditional modeling techniques, starting out at the age of sixteen at the New York Art Students League in 1886. At the age of nineteen, he traveled to Paris, where he studied as a painter at the École des Beaux-Arts. The next two years in Paris led him to select sculpture as his life's work, with studies at both the Académie Julian and Académie Delécluse. After six years abroad, Parry returned to New York and established his own studio and foundry connections, notably with the Henry-Bonnard Bronze Company.

The young sculptor soon secured two important commissions from the new Library of Congress, which raised his visibility as an accomplished sculptor and demonstrated his ability to design, model, and install monumental works. In 1894, he sculpted a series of bas-relief panels in bronze for the doors of the new Library of Congress Building. This was followed by a commission for a new fountain sculpture—*Court of Neptune*—in the front of the building, completed in 1898 with help of sculptor Albert Weinert (who created the reliefs of dolphins and stalactites carved on the retaining wall, while Perry sculpted the fountain's figures). Another commission soon followed in 1899, to model the spandrels on the Dewey Arch in New York.

Two key elements would weigh into Parry's new sculpture for Portland—his technique with respect to large public sculpture and their presentation; and the degree of realism he specifically assigned to animal subjects, and more specifically, an elk.

In his large-scale fountain for the Library of Congress, the figures of Neptune accompanied by nymphs on both sides are collectively shown larger than life, nude and in dramatic poses, with the females on each end riding "merhorses" that gallop and toss

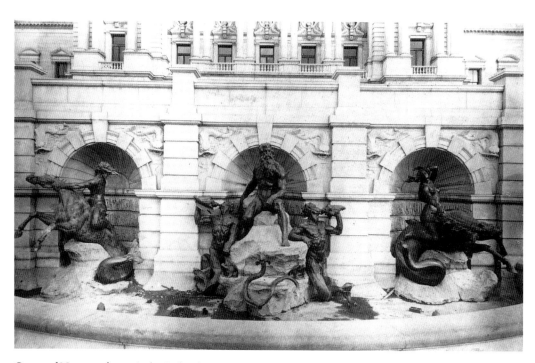

Court of Neptune fountain by Roland Hinton Perry (1898). Bronze-cast sculpture group, Library of Congress, Washington, D.C. (*Photograph 1897–1898 by G. W. Harting. Archives and Special Collections, Smithsonian American Art Museum*)

their heads. The sculpture is done in a style that was Neoclassical (invoking the heroism and forms of Greek mythology), yet modeled with anatomical detail in figures that was correct yet decorative, collectively termed by many as belonging to the Beaux-Arts style. This approach was a hallmark of late-nineteenth-century American sculptors and their formal training.

The *Court of Neptune* fountain also illustrated Perry's skill at taking on challenging commissions. The original sculptor for the Neptune group was George Gray Barnard, who accepted the commission in mid-February 1895. Barnard was recognized in his day as one of only a few American sculptors who was accomplished in working in both marble and bronze. For the Library, he created three different designs, all of which were criticized early on in the process (especially by Bernard R. Green, the civil engineer in charge) for their inclusion of both male and female nude figures, with the final sketches not approved until October.

By January 1896, Barnard had withdrawn from the commission, citing competing jobs at his studio and financial pressure as a result. Perry shortly took over the sculpture work, and by the following February, he had placed the central figure of Neptune into position. For the casting work, he relied upon the Henry-Bonnard Bronze Company foundry in New York, which delivered the south and north nymph groups in October 1897 and January 1898, respectively. The fountain was completed on February 23, 1898.

Perry's views on natural realism balanced with creative flair, where animals were a focus, proved to be a combination of forces in his modeling, with the success of the *Court of Neptune* fountain as one example. In 1913, he voiced this view as part of a discussion concerning another sculpture he had recently completed, an equestrian memorial depicting Confederate Army General John B. Castleman, as well as the role of the American public as an audience:

> The American people are, above all, practical. They like to see works that show things or people as they are, and not as the artist, with his idealistic nature and viewpoint, sees them. Our museums have many wonderful works, but the real inspiration comes forth when we can see an artist work in the surroundings that have inspired it. Now, in the Castleman memorial they were mighty particular about the horse ... usually in matters of portraying animals, the artist is given a certain amount of freedom to use his imagination, but the committee insisted that the horse, or rather the mare, should be reproduced as near to nature as possible. You see, there is an illustration of the American mind-practical.[5]

For the Portland elk sculpture, Perry modeled his design in his New York studio, based upon Thompson's commission of $20,000 to pay for the effort. The degree to which Perry relied upon the natural appearance of a Roosevelt elk is a bit open to interpretation by the viewer. A comparison of the bronze casting made from Perry's plaster model shows a full-sized bull elk, with a full rack and standing with hind legs slightly apart, with the head is slightly turned to the left. The musculature of the animal is clearly detailed, especially in the areas of the haunches, legs, chest, and head. Perry included minute touches, from the size and shape of the horns to the animal's hide.

There remains the question about whether or not Perry observed any living specimens of elk (of the Olympic variety or otherwise) as part of his design process. The composition

of his completed sculpture, and attention to details throughout, would suggest this is likely; at the very least, that the sculptor consulted illustrations or photographs of elk from the North American continent in his studio preparations.

While the final presentation of *Elk* was indeed dramatic and illustrative of a majestic animal, this element of drama was not the result of either over-simplification or exaggeration to the rendering of the animal's true form. Perry appears to have tempered his emulation of Neoclassical forms, with a quality of realism he believed was called for by the New World's citizens. A modern examination of the sculpture, for example, with photographs of live Roosevelt elk in the wild, illustrates that his proportions were correct as far as antlers, torso-to-neck proportions, and leg positioning and size were concerned. A reporter commented on the sculpture's lifelike appearance, a week after its arrival to Portland:

> The casting is a very fine piece of work, representing an elk standing 'at gaze' or in position as if he had just heard the hounds baying on his track. His mane is as natural as life, and even the veins in his legs showing.[6]

Much credit was due to the sculptor's choice of a foundry for the bronze casting. Here, too, we see Perry's knowledge work to his advantage, as his previous connections with the Henry-Bonnard Bronze Company's foundry provided a proven source for the high-quality casting that his patron had requested.

The foundry of choice was originally established in 1871 by the Frenchman E. Henry and P. A. Bonnard, and for thirty years, it carried out its bronze casting operations at 430 to 444 West 16th Street in New York. In 1884, the foundry was taken over by French foundryman Eugene Aucaigne, who supervised the company's operations up until the time of the *Elk* bronze casting in 1900. Having already worked with this foundry on the *Court of Neptune* castings, Perry's foundry choice for the new elk design was a logical one.

Using the French sand-casting method, the Henry-Bonnard foundry cast the sculpture with a finished weight of 6,800 lb. The antlers of the elk were cast separately; they would be attached later to the body of the sculpture at the time of its installation. The foundry was first-rate with respect to artistic bronze casting, equipped with equipment and space for casting sculptures ranging from large one-piece casts like Perry's *Elk* to individual plaques and medallions.

In spite of Thompson's pledge to see the fountain ready by July 4, the completed sculpture was delayed, with the shipment arriving in Portland on July 31, 1900. The day it arrived, H. G. Wright, the contractor for the fountain, had hopes for the sculpture to be fully installed in one week's time. True to Thompson's desire to see it function as a watering source, four drinking troughs for horses and other animals were incorporated into the base around the fountain.

Further delays were still encountered a week later as more caulking and cementing of the fountain's joints needed to be done around its base, which measured 25 feet in diameter. Yet perhaps in anticipation of the event, a local clothier, Sam'l Rosenblatt and Co., announced its Elks' Carnival Donation Sale for Saturday, August 11, with a special appeal made to local members of the Elks lodge to attend. However, the weekend came and went, with the fountain still delayed.

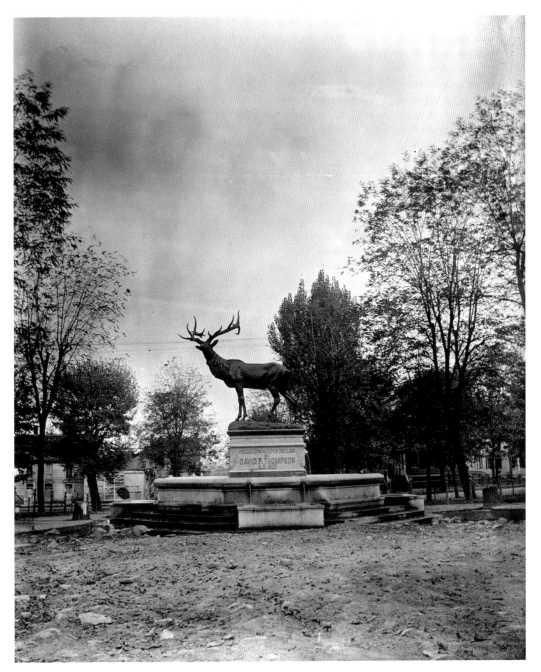

Elk by Roland Hinton Perry (1900; alt. *Thompson Elk Fountain*). Bronze-cast sculpture, Portland, OR. Photograph 1905. (*Oregon Historical Society*)

August 20 saw the sculpture still sitting next to the fountain, sans antlers, with the further delay attributed to the missing capstone for the pedestal, upon which the elk sculpture would stand. On August 22, the city's water committee approved enough water pipe to make the necessary connections to the fountain, in order to make it operable.

The *Elk* sculpture (also known as the *Thompson Fountain Elk*) was finally elevated into position on August 27, 1900, near the Courthouse, located at Southwest Main Street between Third and Fourth Avenues. With the sculpture now in place, all that remained was to connect the water to the city mains and turn it on to make it fully operational as a public fountain.

Both C. E. S. Wood and city engineer Chase accepted the fountain from Wright on behalf of the city. As for the sculptor, no mention of Perry is given in the weekly newspaper updates leading up to or during the final installation on August 27.

Despite the delays, Thompson was satisfied overall with the effort, and expressed as much to both the mayor and city council: "It is believed by those competent to judge such work to be as strong and durable as it can be made, and should be as lasting as the City of Portland."[7] The installation of the sculpture also was marked as one of Thompson's final major accomplishments, with his death just a year later on December 14, 1901.

Not all of Perry's contemporaries were as pleased with the final result. Some of these were among the 7,000 Benevolent and Protective Order of the Elks (BPOE) members who attended the Elks' Day parade held on September 6. Some thought that the legs of the animal were too thin, and the antlers and neck were too long. On a whole, it was the group's opinion that the sculpture was not an accurate presentation of an Olympic elk. They refused to dedicate the sculpture, with many storming out rather than give vocal support to the effort by Perry as sculptor.

There is an interesting corollary story about Perry and the Benevolent and Protective Order of the Elks (BPOE), as well as a possible connection between the *Thompson Elk Fountain* and another series of elk-themed sculptures found nationwide. These are the *Elks' Rest* statuary placed in cemeteries to mark member gravesites of the BPOE members. At its peak, these statues were placed in over seventy locations across the United States in thirty-three states, with the majority of them installed at cemeteries as grave memorials. However, other BPOE Elk sculptures were also placed at municipal locations like public squares or outside Elks Lodges (such as the Grand Lodge in Chicago) as decorations emblematic of the organization.

Each *Elks' Rest* memorial included a life-sized sculpture of an American elk, an adult male with a large rack of antlers, with the design showing the animal standing at rest. At least two versions of the sculpture were made for the BPOE's *Elks' Rest* memorial sites found nationwide. In one design, the head of the animal was shown turned to the left, with the front two legs splayed apart. These sculptures were mounted onto an elevated base of granite or other stone, raised in the air 4–5 feet. Another alternate design, which presented the elk looking straight ahead, was installed at other *Elks' Rest* sculpture locations, either mounted onto small boulders for display around group gravesites or perched atop BPOE mausoleums.

When combined with the placement of the sculpture at or near the center of the gravesite grouping, the effect was one of each *Elks' Rest* watching over the lodge members at their eternal rest.

One of the earliest of these memorials was made in 1891 for the Elks' group gravesite at Cave Hill Cemetery at Louisville, Kentucky, sponsored by the Elks Louisville Lodge No. 8. The initial plan called for this sculpture to be cast in bronze by the J. W. Fiske Company of New York. However, the sculpture was not cast until 1897, done instead by the Henry-Bonnard Bronze Company foundry in New York. No marks were made to the Cave Hill Cemetery's casting, as far as documenting the identity of the sculptor.

Further deepening the mystery was that J. W. Fiske also produced castings in iron and zinc of the same sculpture design as the one found at Cave Hill. These copies were collectively marketed under the title *American Elk*. The company used its own zinc casting works in Williamsburg, Long Island, for those non-bronze versions of the sculpture. One edition sold at a Sotheby's auction in 2016, accompanied by a catalog note that Joseph Winn Fiske was the designer as well as the foundry source for other copies produced of the same sculpture from 1892 to 1920.[8]

The Sotheby's source also indicates that the Fiske design may have been influenced by the work of an earlier Berlin sculptor, Christian Daniel Rauch (1777–1857). The zinc sculptures may have appealed to the Elks as a group for nationwide distribution to sites, as the cost of zinc statues as an offering beginning in the 1850s was more economical compared to expensive castings done in bronze.

The Fiske zinc copies were either installed as *Elks' Rest* memorials for other cemeteries, such as the one on view at Laurel Grove Cemetery in Totowa, New Jersey, or became public sculpture monuments for city parks and squares, such as the one installed in 1899 at Reading, Pennsylvania. It was also the case that some states had more than one casting of *American Elk* as a reflection of different BPOE lodge budgets and other preferences. In several instances, the *American Elk* sculpture was installed outside of BPOE lodges instead of cemetery memorials, further widening their visibility and range as an artwork.

Perry enters into this sculpture's history as a possible contributor to the original design by Joseph W. Fiske. References to the *American Elk* sculpture for the *Elks' Rest* memorial located at Woodmere Cemetery at West Fort, in Detroit, Michigan, have attributed this version to Perry as the sculptor, with the foundry work completed by the Bureau Brothers in New York.[9]

Some copies of the *Elks' Rest* memorial sculpture were produced in bronze, rather than zinc. In the version of the *American Elk* design for Woodmere Cemetery, this version was cast into bronze, identical to the one that was installed for the Cave Hill site. However, a further investigation of this particular *Elks' Rest* provenance makes it doubtful that Perry was responsible for the design of the sculpture *American Elk*.

News articles date the dedication of the *Elks' Rest* sculpture at Woodmere Cemetery to October 30, 1892, in an effort sponsored by the Detroit Elks Lodge No. 34. In this case, the timing would not have been appropriate for the sculptor to have either designed or modeled the sculpture, as Perry has not yet returned from his studies abroad in Europe until two years later, around 1894. Many of the *Elks' Rest* sculptures did not start appearing around the country until the late 1890s.

As a sculptor, Perry did have good connections to the Henry-Bonnard Bronze Company through both his early commissions for the Library of Congress and the *Thompson Elk Fountain* in Portland. However, the identity of the foundry that undertook the bronze casting for the Woodmere Elks' Rest is still in question. The Fiske Company may

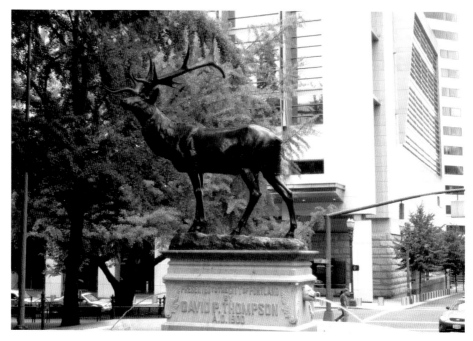

Above: Elk by Roland Hinton Perry (1900). Photograph 2006.

Below: Detail view of *Elk* by Roland Hinton Perry (1900). Bronze-cast sculpture, Portland, OR. This view shows the sculpture post-deinstallation, after its removal from public display in 2020. (*Photograph 2020, courtesy of Brian Libby*)

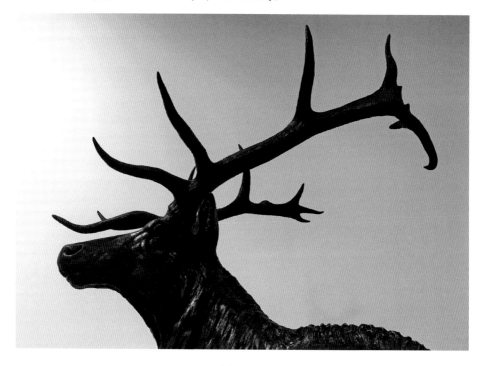

have simply contracted to have the casting design done in bronze by Henry-Bonnard, similar to the sculpture at Cave Hill, which has the foundry's stamp in the side of the pedestal. Fiske was known to outsource casting work in both zinc and bronze, for its designs, patterns, and other ornamental products. Another possibility is that the Smithsonian's record of the Woodmere *Elks' Rest* sculpture is partially correct, in its identification of the Bureau Brothers as the foundry that cast it into bronze. The Bureau Brothers Foundry was originally started around the 1870s, by Achille and Edouard Bureau, in Philadelphia, Pennsylvania. At that time, it was noted for its bronze statuary, architectural works, fountains, window guards, and other decorative metalwork.

One of the sad truths today about the Elks' Rest memorials is that many have fallen into neglect and disrepair, and at least two sculptures—the one at Woodmere, and another previously installed at Forest Hill Cemetery in Memphis, Tennessee—have been vandalized and, in the latter's case, stolen. The Woodmere *Elks' Rest* sculpture was cut off its base and discarded; it has since been removed from public display by the groundskeeping staff.

In 2019, the *Elk* fountain created by Perry was one of ten fountain sculptures scattered around Portland. While the fountain's original purpose as a watering site for animals was outlived by this time, it has remained an iconic symbol of Portland as a city. Recognition of the historical value of the sculpture as part of the city's history was recognized in 1974, when the sculpture and surrounding Plaza Blocks were designated as Historic Landmarks. Since then, *Elk* has made appearances in other creative works set in the Pacific Northwest. The film director Gus Van Sant used the sculpture as a backdrop to a scene from *My Own Private Idaho* (1991) where Keanu Reeves cradles a sleeping River Phoenix in his arms.[10]

While the sculpture has served as a visual legacy to the wildlife of the region for over a century, it became a casualty of nationwide protests and civil unrest in Portland during the summer of 2020, when its stone pedestal was severely damaged by several fires set around its base. The sculpture was removed soon afterward, both to prevent further damage to the artwork and to prevent any injuries to bystanders from a potential collapse of the *Elk* bronze from its elevated display.

While the removal offers an opportunity for the sculpture to receive a more extensive cleaning, its future for public display in Portland represents a new chapter in its history. It remains a beautifully modeled sculpture of a native majestic animal in the region, and one of Portland's first public monuments. It also serves as a reminder of how new commissions for public sculpture were at one time a more simplified process, where key considerations of financial backing, direction of vision, and artistic execution determined the final result.

2

ALICE COOPER
(1875–1937)

In the first half of the nineteenth century, it was difficult (but not impossible) for an American sculptor to gain international recognition in the field. One avenue that did increase a sculptor's chances at success was to gain training in the fine arts either by travel abroad to experience European venues firsthand or through meticulous studies at art schools abroad. Those Americans who took this route, like Horatio Greenough who studied in Italy, looked to major urban developments in which to promote their work. In Greenough's case, this was a decorative group for the east pediment of the new U.S. Capitol Building in Washington, D.C.

Women who were either trained or practicing sculptors in the United States were an even greater rarity. There were scattered examples, such as Patience Wright, who is recognized as one of the earliest women sculptors who practiced in the American colonies. She began in Bordertown, New Jersey, during the Revolutionary War, with the modeling of portrait heads in wax. She later voyaged overseas to England, using her skills in portraiture for the British Royal Family. Her time with the royals ended after she spoke out about the war against her fledgling home country.

At the beginning of the twentieth century, and in the first decades that followed, women's roles and rights took on a new progressive stance, both in the United States and globally. The Suffragist campaign to secure the right for women to vote in Democratic elections was one such area. The arts were another; they reflected some of this progress, with a notable increase in the number of practicing women sculptors creating new public statuary, monuments, and memorials for cities and towns. Portland was one of these, with the arrival of Alice Cooper and her commission to model a new statue for the Lewis and Clark Centennial Exposition in 1905.

The commission for the new public artwork was initiated by another group of women involved in the planning for the exposition. The members of this group, collectively called the "Woman's Club," (later called the Sacajawea Statue Association) had a shared vision to promote women's history of the Pacific Northwest.[1] They accomplished this not only with the selection of a woman as the sculptor—Cooper—but also in the artwork's featured subject: the Lemhi Shoshone Indian Sacajawea (or Sacagawea), the

guide for the Lewis and Clark Expedition from May 14, 1804, to September 23, 1806. The expedition involved a group of U.S. Army and volunteers under the command of Captain Meriwether Lewis and Second Lieutenant William Clark, with the course of exploration ending at Fort Clatsop on the West Coast of the United States (located near Astoria, Oregon).

The timing for the selection of Sacajawea as the figure for the new sculpture in 1904 coincided with an expanded scholarly awareness of the figure and her role as part of the Lewis and Clark Expedition. The evolution of how the Indian guide was documented in the historical record was a matter of progression, leading up to a more visible public awareness of Sacajawea in the late nineteenth century:

> In 1814 Nicholas Biddle and Paul Allen edited and published the journals of Lewis and Clark in one abridged narrative with a very long title: *History of the Expedition under the Command of Captains Lewis and Clark to the Sources of the Missouri, thence across the Rocky Mountains and down the Columbia River to the Pacific Ocean. Performed during the Years 1804–5–6. By Order of the Government of the United States.* The two-volume work came to be known as the "Biddle edition." This edition does not characterize Sacajawea as a heroine, although it does note much of the work she contributed.
>
> Sacajawea's story lay dormant, buried in the original journals that Biddle stored in the archives of the American Philosophical Society of Philadelphia. She was resurrected in 1892 by Elliott Coues ... he published a four-volume work that condensed various expedition journals [Lewis, Clark, Ordway, and Gass] into a single, coherent narrative.[2]

Complementing these efforts, the historian, writer, and Suffragist Eva Emery Dye compiled her treatise *The Conquest: The True Story of Lewis and Clark* in 1903. Dye emerged in a central role as an advocate for the Sacajawea as both a principal in her book and as the focus of the new statue for the upcoming Lewis and Clark Exposition in Portland.

For Cooper, her background as a sculptor was already well established when she received the Portland commission. She was born in 1875, originally from Glenwood, Iowa, and raised in the Midwest city of Denver. Her early training in the fine arts was notable for studies with the American sculptor William Preston Powers. Cooper further expanded her practical knowledge of the medium, working with Lorado Taft at the Art Institute of Chicago. She was also a member of the Art Students League of New York until 1901—a relationship that afforded her connections to both the Pennsylvania Academy of Fine Arts and the National Academy of Design.

For the thirty-year-old Cooper, the commission for the Sacajawea statue presented a significant opportunity to commemorate the identity of a historical female figure, notably a Native American one, through the sculpture medium. Her style in the modeling of the figure was similar in many respects to the Neoclassical themes prevalent in much of the public statuary and other sculpture of this era throughout the United States. It held a high standard in execution, with attention to correct proportions and anatomy, but combined with poses and gestures of the figure that were considered heroic, dramatic, expressionist, and monumental on a grand scale. The Beaux-Arts, too, with its focus on incorporating decorative flair and elements such as flowing robes in the statuary, or allegorical elements symbolic of peace, academia, the four seasons,

or virtues, influenced both men and women sculptors who worked in public sculpture commissions at this time.

Cooper was no different, in her use of styles and imagery to model her full-length portrait of Sacajawea. With no existing illustrations upon which to base the model, she looked to contemporary American Indian subjects to present facial details, both in the main figure and the infant carried on Sacajawea's back (her son, Jean-Baptiste Charbonneau, whose inclusion also represents an acknowledgment of the son's French and Lemhi Shoshone mixed heritage).

Cooper's initial design differed greatly in detail from the final statue. This early maquette, or study, was modeled in clay and completed in 1904. The design depicted the figure of Sacajawea more rigid in her posture; the right arm was also upraised, but at a lower angle, while the gaze of the figure was not upwards, but rather straight ahead and not aligned with the arm. The left arm did not naturally hang at the side but was bent at the elbow, while the posture overall was standing still.

The sculptor subsequently made substantial revisions to this first design attempt, which collectively improved the quality and presentation in the final bronze statue. The revised design was completed in October 1904, with previews calling out "action telling vitality in the model."[3] The redefined pose of the statue was indeed a more dramatic one. The figure's right arm was further upraised, and the head uplifted at an angle that mirrored the position of the right arm aloft. The baby was now shown at shoulder height, instead of slung across the lower back, where it appeared almost as an after-thought in the earlier design. Sacajawea is shown in explorer garb of the early nineteenth-century era, from moccasins adorning the feet to an animal fur thrown around the shoulders. The infant, Jean-Baptiste, is visible only from the face and head, with hands clasped to his mother's left shoulder, as he rides carried in a cradleboard.

The features of Sacajawea are stoic and proud, with the figure's hair worn in braids. The left hand of the statue holds nothing and was presented in a loose posture at the side. The American Indian guide is shown in a posture of forward motion, with the left foot firmly placed forward of the other, in mid-stride. The overall effect is one of motion and purpose combined.

However, the extent of the realistic portrayal of the subject extended only so far. We see how the desire to emulate Neoclassical forms, with its focus on capturing perfection, found its way into Cooper's interpretation of her subject. The statue of Sacajawea presents a figure of beauty and pride, but there is a quality as well that belies the reality of Native Americans living at this time, including the Shoshone.

Ironically, this observation was even apparent to viewers of the Sacajawea statue in its time as a new public artwork. The characterization of the statue by the reviewer presents a sad commentary on how the identity of Native Americans was regarded by some in Cooper's era, even as it sought to glorify both the historical figure and the sculptor's efforts:

> The sculptor [Cooper] has shown fidelity to the traditions of the intrepid woman who led the white men on their perilous journey. The spirit of the immortal Sacajawea is portrayed, and the Bird Woman is lifted by the hands of art from the degrading characteristics which mark the features of her descendants among the Shoshone or Snake Indians of her tribe today.[4]

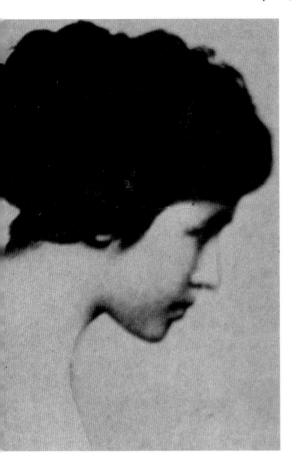
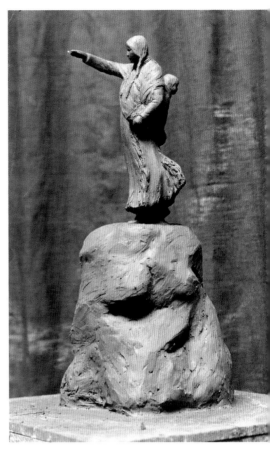

Above left: Alice Cooper, sculptor. Photograph 1904. (*Oregon Historical Society*)

Above right: Model for Statue of *Sacajawea* by Alice Cooper. Photograph 1905. (*Oregon Historical Society*)

The Sacajawea statue was intended as the centerpiece of the exposition held in Portland during its run from June 1 to October 15, 1905, and was much celebrated by the large crowds in attendance. Cooper arranged to have the final design cast into bronze by a foundry in New York, with the casting mold utilizing 20 tons of Oregon copper in the process. The finished bronze cast statue was shipped via rail out west in spring 1905.

The unveiling of the statue on July 6, 1905, was a celebration of women's history, with the assembled audience including many prominent suffragists and their leaders, including Susan B. Anthony, Charlotte Moffett Cartwright, Reverend Anna Shaw, and Abigail Scott Duniway. As part of the public celebration, Anthony, Anna Howard, and Carrie Chapman Catt all made speeches extolling the value of women's history embodied by the new sculpture to the assembled onlookers.

The statue was displayed at the center of the Plaza during the exposition, but at the conclusion of the Centennial Exposition's run, it was relocated as a permanent

public sculpture at Washington Park in Portland. In its new placement, the figure of Sacajawea points westward, another reference to the historical journey undertaken by the Corps of Discovery and its mission to chart the western reaches of the United States to the Pacific Ocean.

During the run of the exposition, and afterward when the statue was placed in Washington Park, the official record of its reception by the public was generally positive. An exception was noted in a newspaper review of the statue years later, when a lone critic, author Emerson Hough, referred to the statue in his novel *The Great Adventure* as "a poor piece of work, erected in the wrong place ... it should have been placed at the head of the Missouri River."[5]

Both during and after the exposition, Cooper's statue received wide acclaim and public support. Prior to the official opening of the Lewis and Clark Centennial Exposition, the Sacajawea Statue Association was formed to oversee the care and public presentation of the new statue. The group included local patrons such as Charlotte Moffett Cartwright, who also belonged to the State Equal Suffrage Association and the Portland Women's Club. In September 1905, the association held a reception in Portland to honor Cooper in person for her artistic accomplishment.

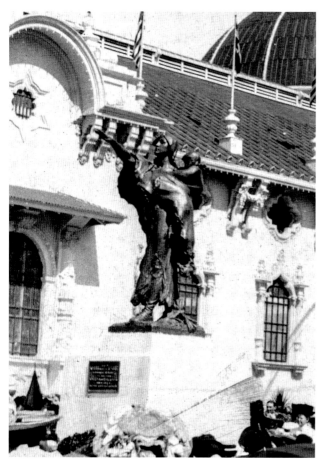

Sacajawea by Alice Cooper (1905). Bronze-cast statue unveiled at the Lewis and Clark Centennial Exposition, Portland, OR. Photograph 1905. (*Oregon Historical Society*)

Ostensibly, the group's importance was threefold. First, led by the efforts of Eva Emery Dye, the group raised funds to commission Cooper to undertake the sculpture. Second, it worked towards the successful transition of the statue to a permanent display in Washington Park, following the end of the exposition. Lastly, it continued to continue the preservation of the statue as a public sculpture in the years that followed.

The Sacajawea Statue Association had originated from the Portland Woman's Club, which raised funds in 1904 for support of the Sacajawea statue. The timing for this around Christmas ostensibly was purposeful in its capitalizing on the giving spirit of the season; it involved coordination as well with other civic groups from around the state:

> The civic committee of the club has been invited this year to co-operate with the Citizens' league, and will no doubt accomplish good results through this alliance. The club lent its services willingly and generously in raising funds for the Sacajawea statue. In October the club entertained the state federation in the most generous and royal manner.[6]

The members' efforts were also aided by Portland businessman Herman Altman, whose financial contributions to the project helped to ensure the statue's timely completion for the exposition.

For Cooper, three important "firsts" factor into the history of the Sacajawea statue commission and her role as the selected sculptor. First, the Sacajawea statue represented her first opportunity for a public art commission. Secondly, it also was the very first public sculpture and artwork by a female artist to become part of Portland's public art collection. Thirdly, it was the first public art sculpture to represent a female Native American in Portland and perhaps the West Coast in 1905.

There were other statues of Sacajawea, albeit not found in Oregon. One bronze sculpture installed in Bismarck, North Dakota, has some of the same basic design and stylistic qualities found in the Portland statue—how it presented the figure of Sacajawea as a young Shoshone woman; she is shown carrying her infant son on her back; the figure is life-sized and portrayed in American Indian dress of the early 1800s. In other details, the statue was significantly different. The figure is depicted in a standing posture, compared to the striding figure of Cooper's statue. The Bismarck Sacajawea also has the figure's right arm curled upward to clasp the sling in which the infant is carried, while the figure's head looking straight ahead. The statue was created by sculptor Leonard Crunelle in 1910 for the North Dakota State Capitol's grounds (the work was formally titled *Sakakawea*, with both *Sacajawea* and *Bird Woman* as alternate titles).

Crunelle is noted for having employed a live model of the Hidatsa Tribe—Mink Woman—in his modeling of the Bismarck statue. In doing so, he captured a naturalism and realism to the portraiture of the subject, which is comparable to the style also achieved in Cooper's Portland sculpture of the American Indian guide. As further testimony to the important role of Sacajawea in American history, another casting of the Crunelle statue was made and installed into the National Statuary Hall in Washington, D.C., in 2003, as one of North Dakota's two official state sculptures.

Other sculptors since Cooper have created statuary that has Sacajawea as the figure. The Oregon sculptor Lorenzo Ghiglieri modeled a bronze sculpture showing a Native

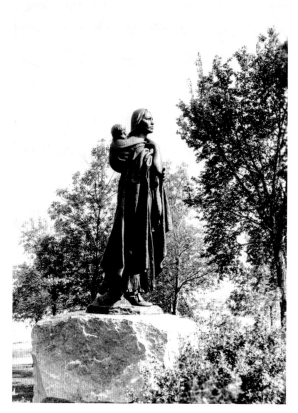

Sakakawea by Leonard Crunelle (1914). Bronze-cast statue located on Capitol Hill, Bismarck, ND. Undated photograph by Russell Reed. (*Oregon Historical Society*)

American woman seated and nursing an infant, titled *The Strongest Bond*. The work was made as a small-scale sculpture or figurine for commercial sale starting in 1982, not as a public art commission or life-sized edition. Several versions of the design appeared on the art market, with the sculpture cast in bronze approximately 2 feet in height.

It is important to note that for Portland, Cooper's statue was not the first public sculpture for the city to portray a Native American figure. That distinction goes to the New York sculptor Hermon Atkins MacNeil, for his bronze statue titled *Coming of the White Man*, installed in 1904, a year prior to the Sacajawea commission.

Right away, the viewer sees many similarities between the MacNeil statue, and Cooper's *Sacajawea*, which came just a year later. Throughout his career as a sculptor, MacNeil focused on Neoclassical and Beaux-Arts as styles in his presentation of figures as monumental (larger than life-sized), posed dramatically, and with a preference for showing as much anatomical detail as possible. All of these same hallmarks are also seen in the modeling of Sacajawea by Cooper. To a large extent, this shared view of the modeling process and its combining dramatic flair with figurative details was an outcome of the European school of arts training, which Cooper and MacNeil both received as sculptors.

In a similar fashion, MacNeil's statue also focused on the expedition of Lewis and Clark, where the two Indian figures presented were modeled with different facial

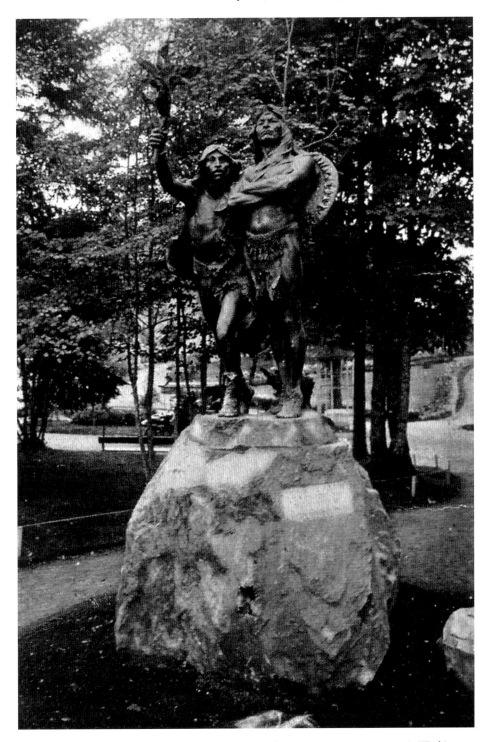

Coming of the White Man by Hermon Atkins MacNeil (1904). Bronze-cast statue in Washington Park, Portland, OR. Postcard photograph, 1904.

reactions to the perceived presence of the American explorers. The figure on the right, identified as Multnomah, a chief of the Multnomah Tribe of the Columbia River, was presented as a stoic form, with arms crossed at the chest and wearing a loincloth and fur headdress. The visage of the chief is a stern one, with a set jaw and a slightly furrowed brow. The sculpture's other figure on the left depicts a brave or warrior, younger in age and appearance, with the legs apart as if in motion, his right arm upraised and holding aloft a war club. The expression of the younger figure is one of surprise and wonderment; his adornments include moccasins on the feet, a fur cape with a hood, and a loincloth.

Finally, both statues had the same media and placement properties—both were installed in Washington Park within a year of each other; both were bronze castings made using the lost-wax casting method; and both statues were installed on top of boulders, raised into the air above visitor's heads, which served to offer more protection as well as emphasized the natural surroundings (a diminished effect if squared pedestals were employed).

MacNeil was known as a sculptor who specialized in statues of Native American figures and subjects. His record of public artworks in this vein included sculptures for the Columbian Exposition held in Chicago in 1892 (MacNeil is purported to have witnessed a group of Indians performing at the exposition as part of Buffalo Bill's Wild West Show).[7] The planning for the Lewis and Clark Centennial Exhibition in 1905 coincided with MacNeil's undertaking of the sculpture, resulting in an opportunity to contribute a new public sculpture with a historical Native American theme as the focus.

The commission for *Coming of the White Man* was sponsored by the family of David Thompson, who gave MacNeil the commission in the fall of 1902. While Thompson himself did not live to see the final result, MacNeil finished his design and accompanied the bronze-cast sculpture to Portland in September 1904. The statue was dedicated in Washington Park the following month, on October 6, 1904. It was the first of its kind for both Portland and the West Coast, as a sculpture with a Native American figurative subject.

MacNeil went on to contribute at least one more additional public sculpture and monument that included Native American figures. In 1927, he received a new commission to design and sculpt a massive memorial for the late Judge Thomas Burke in Seattle. The piece included a large bronze portrait medallion showing Burke in profile, combined with a granite-sculpted column with bas-reliefs and figures carved into both sides. The figure on the right side was modeled after a Native American Indian man, with clothing and hairstyles generalized in the presentation. The completed memorial was dedicated on April 5, 1930, at its permanent site in Volunteer Park.

For Cooper, *Sacajawea* marked an important first step in the sculptor's career, as an artist who could successfully accomplish public art commissions. This period was a relatively brief one for her as a sculptor, but it included two notable designs—a new bronze statue of Almeron Eager for Evansville, Wisconsin in 1907; and a sculpture group for the east pediment of the new U.S. Customs House in San Francisco in 1911. In May 1907, Cooper eloped with Nathan Hubbard, a lawyer from Des Moines, whom she married and relocated to Iowa.

Today, *Sacajawea* remains part of Portland's public art collection and is also recognized as part of the Lewis and Clark National Historic Trail administered by the National Park Service.

3

ALEXANDER PHIMISTER PROCTOR (1860–1950)

From the 1800s, up through the first half of the twentieth century, many Americans regarded public statuary as personifications for shared societal values and interests or as celebrations of well-known public figures as a means of displaying public-styled portraiture for the masses. The selection of these subjects and themes for commissions of new sculptures has reflected this outlook, ranging from military generals, soldiers, sailors, and marines for public war memorials, to portrait statues of U.S. Presidents, mayors, and other political leaders. Explorers and businessmen, the latter representing achievement as captains of capitalism, were also popular subjects. The emphasis on celebrating these figures and themes as heroic, gallant, glorified, and everlasting permeated the consciousness of the nation at a time of its most profound western expansion, industrial growth, and desire to enhance urban landscapes with new sculpture.

This valuation of public sculpture through themes and figures of success was a view shared by the American public, one especially favored by both specific civic organizations and clubs like the Elks, American Legion, and Women's Club of Portland, as well as individual patrons who could afford to finance one (or more) new public sculptures to their liking. The belief that public spaces warranted some sort of municipal oversight for the design, commission, and placements of new public statuary as these were privately funded endeavors was only just beginning to gain traction as a policy and planning approach during the 1920s. Public art as a managed part of urban development, and the forces that decided what kinds of sculptures should be created, would only start to gain widespread public support in the late 1940s, following the end of World War II.

During its height, new public sculpture in American cities focused on figurative subjects, including those in cities like Portland, which often incorporated the work of sculptors who were known to have a specialized area of study or expertise in the medium.

Alexander Phimister Proctor was one of these sculptors. While Proctor contributed many public statues, representing both historical figures and generalized subjects (such as *The Pioneer Mother*), his area of study was on modeling animals, more specifically, horses for equestrian statuary.

Proctor was originally from Ontario, Canada, born there in the early 1860s. In 1865, his family moved to Iowa, with Proctor the fourth son out of eleven total children. He was raised in the West as a pioneer, with his early life spent in Denver, Colorado, when the family settled there in 1871. He loved the outdoors and was an avid hunter and fisherman. This passion for nature extended to his artistic interests as well, where he would bring his sketch pad with him on his hunting forays into the Rocky Mountains and capture details about the game in the process.

Much of Proctor's early work was done with drawings of animals he encountered in the region, such as elk, bison, big-horned sheep, and bears.

In 1885, the artist relocated to New York, to formally study art. Proctor had sold a homestead he had acquired in Colorado to fund the relocation. These experiences included studies at the National Academy of Design, followed by the Art Students League of New York, where sculpture was the focus as his lifelong medium of choice. Another four years were spent in Paris, studying sculpture and the Beaux-Arts style.

Out of these studies, it was horses where Proctor truly excelled in his artwork. His first public sculptures done in the equestrian theme were for the World's Columbian Exposition in 1893 held in Chicago. These two works were titled *Cowboy* and *Indian*, respectively, and they sought to visually define the era of the Old West in America. His statue Indian received high praise, due in no small part to the sculptor's use of a live model, Jack, who was the son of the famous Sioux Chief Red Cloud. Both plaster-cast statues were later moved to public display in Denver's City Park, where they remained on view until 1920.

Proctor's next public sculpture opportunity came when he assisted the preeminent American sculptor Augustus Saint-Gaudens with the commission for a new equestrian statue of General John Logan. Proctor successfully modeled the general's horse for the piece, which was installed in Grant Park, Chicago, in 1897.

Another public sculpture designed as an equestrian monument soon followed. To meet the demand for these new commissions, Proctor opened his first studio in New York in 1900. In 1901, Proctor was again commissioned to assist Saint-Gaudens in modeling the horse beneath General William Tecumseh Sherman in a new equestrian statue for the Grand Army Plaza, bordering Central Park, New York.

The importance of these early collaborations for Proctor cannot be overstated. His ability to model horses in large-scale sculpture established his reputation as a specialist in this regard, which led to new public sculpture commissions with an equestrian focus.

To accommodate these new projects and their clients, Proctor had a new studio built in New York in 1911. Located at 168 East 51st Street (Third Avenue), the building was designed by the architecture firm of McKim, Mead and White. It took up three floors and was a shared space with the sculptor Alden Sampson. The two sculptors were friends and had once climbed up Half Dome in Yosemite Valley together. One of the key design advantages to the new workspace was its enlarged areas where the modeling of large, oversized sculptures could be achieved by the artists.

However, Proctor's long-standing love of the West led him to resettle in Oregon with his family in 1914. For the next two years, the sculptor lived and worked in Pendleton, owing in part to its proximity to live horses and riders in action. Proctor was so engaged with his subjects that he was "constantly and dangerously in the way of the bronco riders, and has a special permit to cut a hole in the roof of his studio for better light."[1]

Right: Alexander Phimister Proctor.
Photograph, *c.* 1878. (*Buffalo Bill Center of the West*)

Below: Indian by Alexander Phimister
Proctor (1893). Plaster-cast statue on view
at the World's Columbian Exposition,
Chicago, IL. Photograph 1893. (*Buffalo Bill Center of the West*)

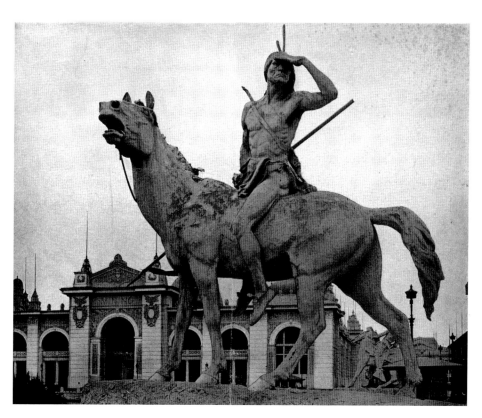

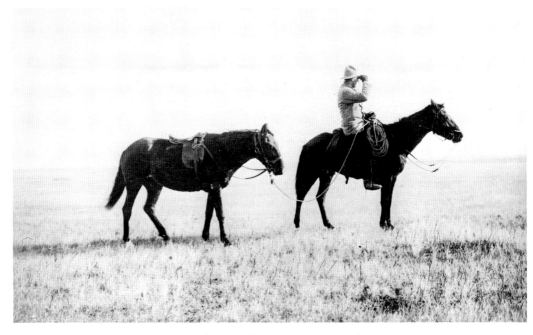

A. P. Proctor on Horseback. Undated photograph. (*Oregon Historical Society*)

It was during this time that Proctor developed a friendship with Jackson Sundown, a Nez Perce and professional rider he met in his earlier travels to Idaho and Montana. At the 1916 Pendleton Round-Up, Proctor paid the entry fee for Sundown to compete in the saddle bronc-riding competition; Sundown won. The figure was a model in two of Proctor's designs for new equestrian sculpture: *Indian Pursuing Buffalo* (1916) and *The Scout* (also known as *On the War Trail*).

Sundown was just one of many live Indian models for Proctor's drawings and sculptures that depicted Native Americans of the Old West. In the case of *The Scout*, completed in 1919, there were three models who posed for the sculptor: Sundown; a second man named Spotted Eagle from the Blackfeet Tribe in Montana; and a third known as both "Big Beaver" and "Red Belt," also from the Blackfeet.[2]

In 1920, Proctor completed one new equestrian monument and began work on another for Portland. The former was a new centerpiece for the Civic Center in Denver, Colorado, titled *Bucking Bronco* (also known as *Bronco Buster* or *Buckaroo*). By this time, Proctor had progressed in being able to model not just horses alone but more complex designs that showed both horse and rider in fine detail. In the Denver design, Proctor captures a moment in motion where a wild mustang tries to throw off the cowboy mounted in the saddle. The horse's rear legs are tucked up, front hooves planted and legs straining, with its head down. The cowboy's right arm is raised high in the air as his left hand grips the horse's mane.

The Denver piece is a good commentary on how much of the public sculpture produced at this time was geared towards the idolization of its subject—making the figure dramatic, majestic, and emblematic of a cause or historical event—and were created as a form of

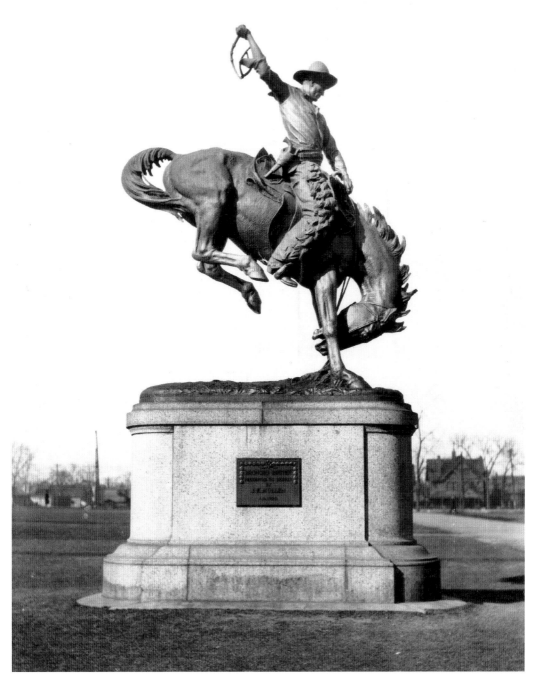

Bronco Buster by Alexander Phimister Proctor (1920). Bronze-cast statue, Denver, CO. (*Buffalo Bill Center of the West*)

"hero worship" with respect to the identity of the sculpture as a portrait figure (in the case of monuments and memorials of specific people). In *Bucking Bronco*, the figure being immortalized is the concept of the cowboy as a romantic figure of the Old West. Much of Proctor's inspiration for the Denver sculpture was derived from his earlier years attending the Pendleton Round-Up in Oregon, with its live action involving cowboys riding wild horses.[3]

For the new Portland equestrian sculpture Proctor began in 1920, the commission called for a hero of the times, one who was recognized by many as a national leader: President Theodore Roosevelt. This commission for the new statue was a privately funded one, with the patron, Dr. Henry Waldo Coe, a prominent physician and influential civic personage in Portland.

Coe was similar in some respects to David Thompson, another Portland public arts patron who preceded him. Coe's vision of public sculpture was one in which he provided not only the funding to make such works possible, but also the conceptual focus of the artwork for the sculptor to fashion into reality. His preference for Theodore Roosevelt as the sculpture's focus was influenced by his personal connection to the figure, whom he had known as a personal friend.

That Coe regarded Roosevelt as a hero in his time (and desired the commission to reflect this) became evident in the modeling Proctor did for his new statue. The overall scale of the sculpture was massive, with Roosevelt presented sitting in the saddle astride a horse, wearing his U.S. Army cavalryman uniform. Overall, the height of the statue was 13 feet tall, with the effect of its imposing presence enhanced further by placement upon a pedestal, which raised it nearly another 10 feet into the air.

Unlike the Denver sculpture of horse and rider, Proctor made the design for the Roosevelt equestrian a more traditional military memorial in its pose. The portrait is a historical visual commentary about Roosevelt's role as a leader of the "Rough Riders" during the Spanish–American War and his leading the charge up San Juan Hill in Cuba. The horse is shown at rest, its front legs together and back legs slightly spread apart. Roosevelt grips the horse's reins in both gloved hands, while sitting erect in the saddle, and looks to the left with his head turned that way, as if something has just caught his attention. The title of the sculpture brings the full identity of the figure home to the onlooker and linked Roosevelt's role in the campaign forever to the sculpture as a public artwork: *Theodore Roosevelt, Rough Rider*.

By September 1920, Proctor had completed his first sketch for the sculpture, with plans to construct a preliminary model 6 feet high as the next step. Estimations put the construction of this study at six months to complete, with the larger monumental-scale model to follow in his New York studio.[4]

Like Coe, Proctor also shared a personal connection to Roosevelt, which greatly aided in his modeling process for the new equestrian statue. The sculptor first met Roosevelt in 1893, when the sculptor had accepted an invitation to the Boone and Crockett Club's cabin (Roosevelt co-founded the club as the nation's first wildlife conservation group in 1887 with George Bird Grinnell). Over the years, Proctor had numerous photographs taken with the Roosevelt during the time the two spent on hunting trips, from which to draw portrait design references. Roosevelt also commissioned Proctor to complete several sculptures for the state dining room at the White House.

While the choice of subject and financing were both steps orchestrated directly by Coe, he was cognizant of the needs of involving the city as far as the placement of his

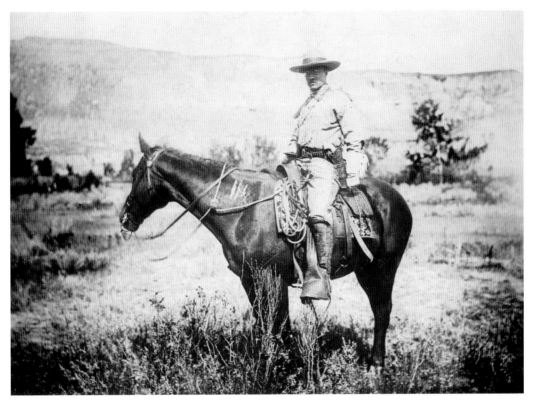

Untitled (Theodore Roosevelt in Buckskins). Photograph 1885. (*Theodore Roosevelt Collection 520.14-008 (olvwork437099), Houghton Library, Harvard University*)

donated public sculpture. A story about the commission noted his approach to this in the fall of 1920, albeit one that still implied his control over this aspect as well: "The location for the completed statue has not been chosen by Dr. Coe. He will talk the matter over with city authorities before he makes a definite choice."[5]

The city council later passed resolution no. 12956 on September 13, 1922, which approved placement of the new statue on the block bounded by Jefferson, Madison, Park, and West Park Streets. The city's official endorsement came just one month after President Calvin Coolidge had visited Portland, to break ground on the site of the statue's placement.

On Saturday, November 11, 1922, the new equestrian statue was unveiled to the public in downtown Portland, in the same South Park Blocks section of the city as the *Thompson Elk Fountain*.[6] By no mistake, the timing was done to coordinate with the Armistice Day celebration in Portland and nationwide. Proctor attended the dedication and remarked on how details seen in the final work tied directly to the identity of President Theodore Roosevelt as a war hero and younger man with a more streamlined physique:

The uniform is more picturesque than the riding habit and I believe it was the war that made Roosevelt President. In 1894 and thereabouts Roosevelt was not the

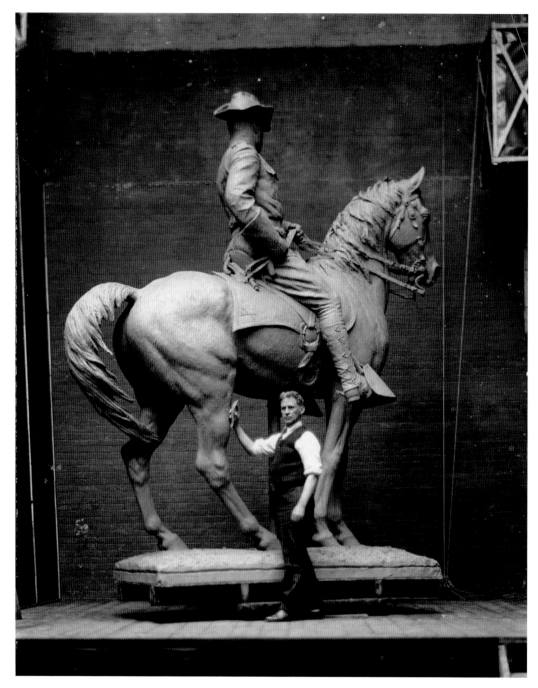

Sculptor A. P. Proctor with plaster-cast *Theodore Roosevelt, Rough Rider*. Photograph *c.* 1920. (*Oregon Historical Society*)

man physically that was during his presidency when people knew him better … one of my motives in sculpturing the Roosevelt of that period is that it was his most picturesque time.[7]

To enhance its public display, the equestrian statue was mounted onto a rectangular granite pedestal, which measured 6 feet wide, 15 feet long, and 9 feet 6 inches high. Two bronze plaques adorned the north and south faces of the pedestal, honoring Roosevelt during his time as a colonel cavalry officer.

Proctor had employed other methods during the modeling process that aided him in portraying a realistic view of Roosevelt. He borrowed two cavalry uniforms from Roosevelt's wife, both of which had been worn by the leader of the Rough Riders during the San Juan campaign in 1898. The sculptor then selected a model to pose in the uniforms, who approximated the size and physique of Theodore Roosevelt at age thirty-nine.

As expected, the sculptor had excelled in his representation of Roosevelt's steed. This was most likely an easier task for Proctor, given his established knowledge of horses and how to convey them in a realistic pose and appearance. He applied the same due diligence to selecting a live animal to model for the statue, an approach that while subjective, was commended by those closest to the president:

My reason for choosing that type of horse for Roosevelt's mount was that I was sure it was the kind he would have liked to ride. I was not wrong, for his son said when he viewed it that it was almost exactly like a horse his father had owned.[8]

Between Proctor's expenses as the sculptor and the bronze casting cost, the total cost of the equestrian statue was nearly double that of the *Elk* sculpture installed two decades before. As the primary financier for the new statue, Coe paid a hefty price of $40,000 to have the work completed. For its part, the city invested $4,800 from its Park and Boulevard Construction fund to pay for the granite pedestal. In a sign of further support and recognition of the statue's significance, the public area surrounding the Roosevelt equestrian became formally known as Roosevelt Square on July 11, 1928.

During his lifetime, Proctor had two other, smaller bronze copies of *Theodore Roosevelt, Rough Rider* created for the cities of Mandan and Minot, North Dakota. The historical connection to the state comes from a period of time from 1884 to 1886, when Roosevelt was there to improve his health and try his hand at ranching. It was during this time that he also first met Dr. Coe, who had begun a medical practice in North Dakota in 1884. The two men became friends and spent time hunting together. Roosevelt and Coe had political connections to one another as well: Roosevelt was deputy sheriff of Morton County, which at the time extended to the Montana border, and lived in the district Coe represented in the Dakota Territorial Legislature.

A third sculpture was cast from the same mold many years after Proctor's death and dedicated in Oyster Bay, New York, on October 29, 2005.

The sculptor contributed two other major equestrian statues for patrons in Portland, but neither of these were intended as permanent public displays: *Indian Warrior* (first cast in 1900); and another equestrian statue, *Indian on Horseback*, for an exhibition sponsored by the Portland Art Association in 1911.

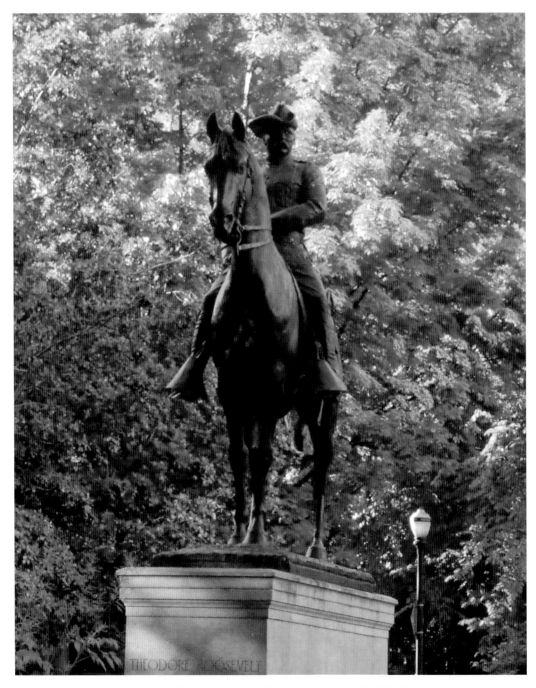

Theodore Roosevelt, Rough Rider by Alexander Phimister Proctor (1922). Bronze-cast statue, Portland, OR. Photograph 2008. (*City of Portland Archives & Records Center*)

Proctor continued to model equestrian subjects for other cities, as well as figurative sculpture for public spaces that were a mix of both historical portraiture and allegorical themes. Another equestrian sculpture for Denver was completed at the same time as the Portland sculpture in 1922. Titled *On the War Trail*, it depicted a Native American rider on his horse, with the figure holding a spear in the right hand. Proctor continued his work in this vein next with a grouping of wild horses for the grounds of the University of Texas in Austin, titled *Mustangs*, in recognition of the school's mascot in 1948.

Other numerous examples of Proctor's work in public equestrian sculpture have demonstrated his abilities and prolific focus: *The Circuit Rider* near the State Capital Building in Salem, Oregon, in honor of early Methodist missionaries in Oregon (cast in 1923, dedicated in 1924); *General Robert E. Lee* in Dallas, Texas (cast in 1936, alternatively known as *Robert E. Lee & the Confederate Soldier*; the city transferred ownership with the sculpture removed from public view in 2017); *Pioneer Mother*, located in Penn Valley Park, Kansas City, Missouri (cast in 1927); and *Sheriff Til Taylor* in Pendleton, Oregon (modeled from a studio the sculptor worked from in Belgium in 1927, cast in 1928). Two other sculptures in bronze installed on the campus of the University of Oregon in Eugene—*The Pioneer* (1919) followed by *The Pioneer Mother* (1932), both examples of early settlers to the Willamette Valley in the mid-1800s—were vandalized in 2020 and subsequently removed from public display by the university's administration.

While the Roosevelt equestrian sculpture helped to solidify Proctor's legacy as a sculptor who brought the Old West to life for succeeding generations, it also marked the beginning of the end for an era with respect to public sculpture in America. The traditional methods for the selection and promotion of public sculpture were changing even in Proctor's time, with new ideas, outlooks, and interpretations of art, history, and heritage all forces that impacted the development of Portland's public sculpture landscape as the twentieth century progressed.

4

EMMANUEL FRÉMIET
(1824–1910)

During the decade of the 1920s, the public sculpture scene in Portland was driven by several criteria often found in other American cities at this time. A marked preference for both the Romantic and Beaux-Arts styles—realistic regarding the anatomy of a figure, but dramatic in presentation and pose—as well as the personalized preferences of specific individuals, donors, or groups, often directed the course of public statuary from the concept phase to installation. Yet other factors were seen time and again, with respect to the process by which public sculpture came into being.

One method employed to promote popular figurative public sculpture was through patrons and their support of the proliferation of the same sculptor's work in multiple locations. It could be one donor or group advocating for several different pieces of statuary by a specific sculptor who were responsible for additional pieces that followed for the same city. In other cases, like war memorials, copies of the same statue were installed in multiple locations across the country, achieved over time and by different groups and patrons.

One example of the former was *The Hiker*, by the sculptor Allen George Newman, which depicted a lone American infantryman representing those soldiers who served in either the Philippine–American War or the Spanish–American War, conflicts that both occurred immediately prior to the turn of the twentieth century. Veterans groups from around the country sponsored this statue as a new addition to their cities in parks, squares, and other public venues in over thirty different locations ranging from Seattle to Providence, Rhode Island.

Over time, multiple copies of the same statue have been in demand for non-military statuary subjects as well, such as the design for *The Ideal Scout* by Robert Tait McKenzie, discussed later in this book.

Two other important factors weighed in a similar fashion. First, the subjects of these new public sculptures were oftentimes either derived from figures of distinct European culture and history or were adopted from earlier Greek and Roman pantheon of gods and mythology. Secondly, when we find an instance where one new public sculpture has been successfully installed into a city's urban landscape, it may herald the beginning of a process whereby a second (or more) new statue quickly followed suit.

All of these criteria apply to the equestrian statue titled *Jeanne d'Arc* (also called *Joan of Arc* and *Joan of Arc, Maiden of Orleans*), which was privately commissioned by a donor in 1924 for Portland, from an original design by the French sculptor Emmanuel Frémiet.

The patron was Dr. Henry Waldo Coe, who first saw the original equestrian statue on display outside the Place des Pyramides in Paris, France, during a visit to that city. Coe had made his first contribution as a donor to the city's public sculpture with the equestrian statue of Theodore Roosevelt, completed just two years before. By the time it was finished, the *Joan of Arc* sculpture was the second of four public sculptures Coe would eventually secure for the city of Portland between 1922 and 1928.

The selection of Joan of Arc as the figure for a new sculpture by an American patron owes as much to the figure's history as it does to Frémiet as an accomplished sculptor of international reputation. As a French heroine, Joan of Arc represented an ideal that Coe wanted to emulate as an artistic example for his own city. It reflected a wider preoccupation with classical ideals of beauty, strength, perseverance, and leadership, which was sought out at this time by American patrons seeking affirmation of their heritage and their shared history. The visual tradition of celebrating Europe's heroes, both real and from antiquity, was one that prominent groups and individuals of the "new" cities and towns of the United States wanted to see made whole. This was especially true following the end of World War I, after America had suffered losses from coast to coast. What better way to memorialize the fallen than through the sculptor's medium of bronze, stone, and marble?

Emmanuel Frémiet. Photograph, *c.* 1875.
(*Chocolats Felix Potin (1908)*)

Jeanne d'Arc by Emmanuel Frémiet (1874). Equestrian gilded-bronze and copper statue in Place des Pyramides, Paris, France. Photograph 2007.

Frémiet's original design for the *Joan of Arc* in Paris was made as a gilded-bronze and copper equestrian statue, intended for public display after its first casting in 1874. The commission for the Paris sculpture came from Napoleon III in 1871, who admired Frémiet for the sculptor's ability to model animals in bronze. The figure of Joan of Arc was a symbol of both military triumph and national pride, one which Napoleon was quick to identify as a symbol of his own prowess as a military leader. It was the only publicly commissioned sculpture by the state between 1870 to 1914, a period referred to sometimes as the "Golden Age" of statuary in Paris.

Coe viewed the Frémiet design outside the Place des Pyramids in Paris, during a visit to France in 1924. This version of the equestrian sculpture had a recasting of the horse done in 1899 from another version the sculptor had created for the city of Nancy in 1889.

The sculptor presented the figure astride a warhorse, wearing plate armor and holding aloft a banner in the right hand as she rode into battle during the Hundred Years' War. Her death in 1429 marked her ascendency as both a martyr and a heroine, with a national identity that endeared her to many as the "Liberator of France."

For Coe, the patron and donor of the Joan of Arc statue copy, his choice of this figure marked a similar trend in how it sought to establish a new nationalism through public art, one that combined elements of European identity and Neoclassical style through its direct adoption of a famous leadership figure from French history. The statue also symbolized the close relationship that existed between American servicemen and French soldiers, as allies who had shared a common battlefield during World War I.

We can see how general patterns to public sculpture emerged in the United States, which reflect this "borrowing" of cultural traditions to create a new visual narrative in U.S. cities. From the 1880s to about 1910, this timeframe was one in which American sculptors looked to classical themes and figures, gods, and goddesses of the Greek and Roman pantheon to decorate public squares, building façades, and street corners. This was a process that occurred from coast to coast, as well as in major cities in between. Roland Hinton Perry's sculpture group featuring Neptune, the Roman god of waters and the sea, as the centerpiece for the new Library of Congress building fountain was one example. Another was the proposal by Clarence Bagley and the city fathers of Seattle in 1907 to have a new sculpture fountain installed with the Roman god Mercury at the center, a concept that the sculptor James Wehn instead turned into a statue of the city's namesake, the Suquamish Chief Sealth.

The adoption of classical figures from antiquity for new American public sculpture went through a major shift with the advent of World War I and the nation's entry into that conflict. After 1918, veteran groups, civic committees, patrons for commissions, and the sculptors they worked with initiated a new focus on war memorials, military leaders, and monuments to past conflicts both at home and abroad, with statuary as a way to honor or promote either specific personages or as testimonies to those who had served and died as a result. This period lasted well into the 1930s, with many public sculptures installed throughout the United States, including Portland.

It was shortly after this new period of military-themed sculpture began that Dr. Coe's first commission for Portland was completed—an equestrian statue of his friend, Teddy Roosevelt. The statue presented another military figure of fame as its model for a West Coast city, focused on an original American icon, which contributed to the establishment

of a new nationalism through public sculpture. All of the three statues that followed the Roosevelt equestrian in 1922 (including the Frémiet *Joan of Arc*) only reinforced this approach to creating a specific public sculpture narrative visually for the city.

There are some interesting similarities and differences between the Frémiet copy of Joan of Arc and copies of other statuary that were made for other U.S. cities at this time. For instance, while *The Hiker* had been recast in bronze dozens of times into three different display sizes, these were copies authorized by the sculptor, Newman, during his lifetime, with his involvement in the placements around the country. The equestrian statue of Joan of Arc was also copied for Portland from the original 1874 sculpture in Paris—four additional copies were produced for sites in Nancy, France; Philadelphia, Pennsylvania; Melbourne, Australia; and New Orleans, Louisiana.

However, by the time Dr. Coe had made his commission for the new work, Emmanuel Frémiet had been deceased for over a decade. The foundry that made the recast was also located in France. In each case, the sculptor had no active role or involvement in any of these later commissions of his original Paris design.

In the case of the Frémiet's equestrian statue, the history or provenance of the copy made for Philadelphia is even more convoluted. A member of the French community in the city commissioned the sculptor in 1889 with the help of the local Fairmont Park Art Association to have Joan of Arc cast into bronze. The contract made with Frémiet stipulated that only three editions of the statue would be made—the original statue in Paris; one for display in Nancy, France; and the third for Philadelphia, near the Girard Avenue Bridge.[1] Yet despite this commission stipulation, three more copies of the statue were made years later after the death of the sculptor, including the one for Portland.

That Frémiet's design was copied without his input for new public sites speaks to how artist rights—in particular, sculptors with public art already on view—were sometimes regarded in both the nineteenth and twentieth centuries, in cities of both Europe and in the United States. In one sense, it was another kind of appropriation that was done in the name of the "greater good" for American public art and the vision of its patrons. It went one step beyond merely copying the Neoclassical and Beaux-Arts styles of a sculpture into a new artwork. Furthermore, this appropriation of European sculptors' existing works and designs for new American cities and American patrons was a practice generally accepted by the public without query or in-depth review.

Another good example of this was the large oversized bust in bronze showing James Hill, the railroad industrialist, made by the Norwegian-American sculptor Finn Frolich in 1909 for the University of Washington campus. Frolich's design, which was based upon live modeling of Hill for its portrait, was later remodeled and recast as an enlarged bust over 20 feet in size by the Seattle sculptor James Wehn in 1925. The patron for this new copy was the Great Northern Employees' Club in Superior, Wisconsin, which could directly trace its historical ties to Hill as the owner of the Great Northern Railway. Whether or not Frolich was involved with this recasting of his work by another sculptor is unknown—Frolich was living in California by this time—but unlikely as a joint venture, especially as news articles of the time made no mention of Frolich as the source of the original sculpture.

There are numerous other examples of American public sculpture that falls into the category of having one or more copies made for other locations after the death of the sculptor. The circumstances that determine the timing and placement of these

new sculptures are as varied as the sculptors themselves; they are the result of good deliberation, civic review, planning, and input where their sponsors are concerned. The question of who owned the rights to a sculptor's designs—whether this was the artist's heirs or estate, or some other third party—added yet another level of complexity where the legality and ownership of copies of public sculpture were desired.

A good example of this is the monumental bronze of the Viking explorer Leif Erikson by August Werner in Seattle, installed under Werner's watchful eye at Shilshole Bay Marina in 1962. This 10-foot-tall statue was later recast in bronze three more times for other locations, including Werner's home country of Norway (1997), Greenland (2000), and Newfoundland, Canada (2013). All of these were completed after the sculptor's death in 1980, through efforts led by the local Scandinavian community in Ballard and supported by leaders and representatives of each community abroad. In each case, there was clear recognition and consensus that the figure of Leif Erikson had strong cultural ties and a historical connection to each new site, similar to how Nordic immigrants had a strong connection to the Pacific Northwest. This context offered a good opportunity to feature a logical visual connection between the statue and each site, something that Werner would have endorsed even during his lifetime as a staunch advocate of old Norse history and artistic expression.

The adoption of copies of one sculpture design for multiple locations is just one possible approach used either by sculptors during their lifetime or patrons seeking to avail themselves of a sculptor's work after they are gone from the picture, so to speak. Another approach to sculpture as public art is when a sculptor creates a series of different designs for different cities, but with a unifying theme or figure as the focus.

An example of this approach is the *Celebrating the Familiar* series of statues by the sculptor John Seward Johnson. In Johnson's case, he has maintained a clear title to the copyright of a sculpture titled *Allow Me* as a public sculpture for Portland, which was installed in 1983, where an adult male figure is shown in modern businessman attired of suit and necktie, and posed holding an open umbrella. Johnson has described the series as an exploration of the "mini-heroics" of everyday life.[2] The placement of the Portland sculpture in the downtown business area ties directly into the sculptor's original vision of calling attention to the ordinary moments of everyday life.

With the Portland *Joan of Arc* statue, personalized connections between the sculptor and the sculpture's focus (whether an original, a copy, or part of a series), or even the sculpture's location, were not a factor given that the sculptor himself was deceased and the figure being portrayed was a historical one in a true sense. What is more likely here is that the Joan of Arc statue fit into the larger narrative of military memorials taking place throughout the nation at this time. At the time Coe began his quest to secure a copy of Frémiet's design for Portland, America's "war to end all wars" had only ended four years before. Moreover, the figure of Joan of Arc was undeniably linked to the campaign, with news reports from wartime reporting how Joan of Arc was an inspiration for the French people and their soldiers on the front lines. The widespread importance of the figure and public recognition of her was manifest in any number of ways: from her review by the College of Cardinals at Rome in March 1918 to become canonized with sainthood, to stories retold by French veterans of having visions of her "in shining armor" the night before the Battle of the Marne.[3]

Public relief that the war was over, advocacy of veterans' groups for public war

Allow Me by Seward Johnson (1981). Bronze-cast statue in Portland, Oregon. (*Image courtesy of The Seward Johnson Atelier. Photograph 2018 by Fred F. Poyner IV*)

memorials, and civic-minded patrons looking to show their national pride were all factors that spurred along new public sculptures across the country. The public statues that celebrated the Maid of Orléans were yet another outpouring of this public sentiment, on both sides of the Atlantic. Besides the Frémiet copy, others were installed in quick succession.

On January 6, 1922, both President Warren Harding and Secretary of War John Wingate Weeks presided over the unveiling of a new equestrian statue *Jeanne d'Arc* at Meridian Hill Park, in Washington, D.C. (this new sculpture itself was a copy of an original statue already on display at Rhimes Cathedral in Paris). This equestrian statue was originally made by the French sculptor Paul Dubois; it was a gift to the American government from the Society of French Women of New York.

Another bronze statue of Joan of Arc on horseback, holding aloft her sword, was donated by the Joan of Arc committee of New York to the people of France in 1921. This equestrian statue by the American sculptor Anna Hyatt Huntington was installed at Blois-sur-Seille in eastern France. Huntington's work for France was a copy, as well, of an original equestrian statue installed at 93rd Street in New York—an example of an American sculptor's work being copied for a city in France.

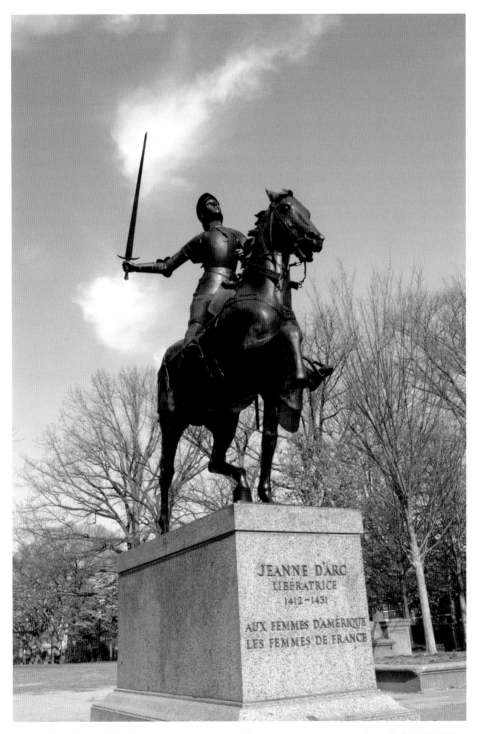

Jeanne d'Arc by Paul Dubois (1889). Equestrian bronze-cast statue copy installed in Meridian Hill Park, Washington DC (1922). Photograph 2012.

Above left: Joan of Arc by Anna Hyatt Huntington (1910). Equestrian bronze-cast statue copy installed in Blois-sur-Seille, France (1921). Photograph 1923. (*Library of Congress.*)

Above right: Joan of Arc by Anna Hyatt Huntington (1910). Equestrian bronze-cast statue in New York. Photograph 2010.

The location of Blois-sur-Seille saw the installation of an earlier, second bronze statue of Joan of Arc by Adolphe Roberton in 1895, which showed the warrior figure clad in armor without horse, with her left hand posed over the heart while the right held a banner.

Another equestrian sculpture of the heroine by the sculptor Denis Foyatier was installed into a public square, Place du Martroi, in Orléans, France, in recognition of the figure's historical ties to the city as the leader who defeated the English forces at the siege of Orléans. Foyatier's massive sculpture was over 14 feet tall and presented the figure astride a horse, holding her sword in her right hand, pointed downward. In a nod to the city, the sculptor gave it the formal title, *La Pucelle d'Orléans* (*Maid of Orléans*). As with the other public statuary, Joan is shown wearing plate armor, with this rendition including a breastplate, greaves, and an armored helmet, with the visor open.

It took Dr. Coe three years from the time of his efforts to secure a new equestrian statue for Portland to the moment when the gilt-bronze copy was finally installed at Portland's Northeast 39th and Glisan Street in the Laurelhurst neighborhood. The statue

Jeanne d'Arc by Denis Foyatier (1855). Equestrian bronze-cast statue in Orléans, France. Photograph 2013.

was raised to an overall height of 13 feet on a granite pedestal, dedicated on Memorial Day, May 30, 1925. The public ceremony reinforced the visual narrative of the new sculpture as a war memorial, with its dedication "in honor of the U.S. Doughboys" who had fought in France during World War I.[4] It received national and international recognition as such, with messages delivered by both President Calvin Coolidge and President of France Gaston Doumergue.

In 1972, with the issue of Frémiet's copyright to the original equestrian statue long past as a concern (expired) another gilt bronze copy of his *Joan of Arc* was cast and given by the people of France to the city of New Orleans. In May 2002, the equestrian statue was rededicated after a three-year effort to restore its condition.

The adoption of Joan of Arc as a military hero for public sculpture on display in several American cities speaks to the continued legacy and cultural ties between the sculpture of Europe, its sculptors, and patrons of the United States. In the case of Portland, it marked the second public sculpture donated by Dr. Coe, with two more to follow in quick succession.

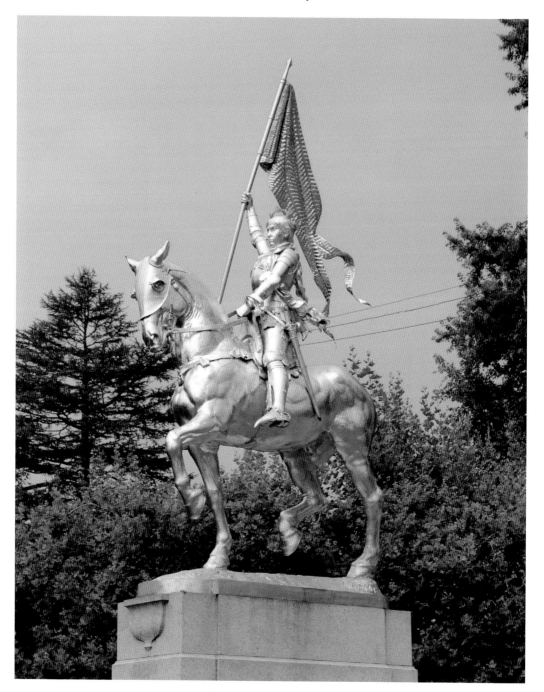

Jeanne d'Arc by Emmanuel Frémiet (1874; alt. *Joan of Arc*; *Joan of Arc, Maiden of Orleans*). Equestrian gilded-bronze & copper statue copy installed in Portland, OR (1925). Photograph 2015.

5

GEORGE FITE WATERS
(1894–1961)

The patronage that the city of Portland enjoyed through the donations of public statuary by Dr. Henry Waldo Coe began with the equestrian statue of Roosevelt in 1920. In all, four public sculptures may be credited to him as the commissioner, which became part of Portland's public art landscape from that era lasting up until the present day. His third statue, a bronze of President George Washington, was completed by the Italian sculptor Pompeo Coppini and installed in northeast Portland. It was dedicated in the city on Independence Day, July 4, 1927.

The timing of the commission for the Washington statue was deliberate by Coe and part of his broader vision for the city. Taken collectively, he regarded his donations of sculpture "with the hope and expectation that other men and women might be stimulated by his gifts to do something worthy for their city."[1]

It was in this spirit that Coe commissioned his fourth and final public sculpture for Portland. He formally presented his offer of a statue of Abraham Lincoln to the Portland city council on December 19, 1924, under the condition the city would bear the expense of the site mounting and base for the statue. This appeared to be a reasonable request, one that the city had previously agreed to, with respect to his donations of the George Washington and Joan of Arc statues.

For placement, the Lincoln statue was destined to join two other Coe donations placed in the South Park Blocks area—the equestrian statues of Theodore Roosevelt and Joan of Arc. This new commission was similar to the others in that the new statue was to be monumental in size and cast into bronze. Coe's choice was the sculptor George Fite Waters, who was engaged to create a preliminary study for the statue while engaged at his Auteuil Studio in Paris.

There were four statues total, which figured prominently into Coe's vision to beautify the city of Portland with new public sculpture. Yet his choice of these historical figures to have cast into bronze reflected factors larger than one man's own personal preferences with respect to public sculpture when viewed on a national scale.

Statues, plaques, and sculpture busts of President Abraham Lincoln were especially in demand for public spaces throughout the United States, even during Lincoln's own

lifetime. The day before Lincoln won the Republican nomination for U.S. President in Chicago, 1860, the American sculptor Leonard Wells Volk patented a design for the first sculpture bust of Lincoln. Volk continued the focus of this work by casting Lincoln's hands and a life mask, with the latter serving as the inspiration for the bust. These earliest works helped later sculptors create more statuary and sculpture with accurate figurative details of Lincoln.

Between 1860 and 1943, there were 137 statues, busts, plaques, statuettes, and other portrait studies of Abraham Lincoln modeled by American sculptors.[2] Many of these were commissioned public sculptures, installed in front of courthouses, in school courtyards, in city and township squares, and other public spaces across the nation. These ranged from both studio-cast and foundry-cast works in plaster and bronze to a variety of others rendered into marble, granite, limestone, and stone. Many of these were either on the East Coast, with concentrations in Washington, D.C. and New York, or throughout the Midwestern states, including Lincoln's home state of Illinois.

The West Coast had several Lincoln public sculptures as well—a total of eight between 1860 and 1927. To the north of Portland, the sculptor Alonzo Victor Lewis created two oversized statues of Lincoln for Washington State: one for Tacoma (1915–1918) and another for Spokane (1921–1930). In San Francisco, the sculptor Haig Patigian modeled a bronze sculpture in 1926. The sculptor A. Frilli created a marble sculpture for the DeYoung Memorial Museum in San Francisco (1915) with a copy of this same work completed for Lithia Park, in Ashland, Oregon. To these numbers and locations, Waters added his 10-foot-tall statue of Lincoln for Portland, Oregon, installed in 1928.

In the 1920s, a vast majority of American could readily identify Abraham Lincoln as a historical figure, one who had been a trusted leader—stoic and admirable, a figure of American history and trial, who proved time and again to have moral conviction, strength in the face of adversity, and was a war hero in the sense of having saved the country from self-destruction. The proliferation of statues honoring Lincoln in the decades that followed the end of the Civil War was in itself a testimony to recognizing his greatness and worth as a figure identifiable through public sculpture—one that was worthy of both preservation and remembrance and has stood the test of time.

In his study of Lincoln sculpture, historian Donald Charles Durman has noted the powerful effects of Lincoln statuary upon American citizenry:

> The admirer of Lincoln cannot stand before one of the statues of that great man without having a sense of Lincoln's presence and wondering what he might say if he were suddenly brought to life. The people who have spoken in dedicating the statues have apparently felt the same and have tried to convey to their hearers the thoughts which Lincoln might have voiced.[3]

Lincoln sculptures represented one example of how citizens of the United States sought to define their patriotism, their heritage and history, and most importantly, their values as a people, through public art. In this regard, and in the eyes of those commissioning these works, Lincoln as a historical figure represented the best aspirations of Americans collectively as a people. The nation's pride was one that sought out this representation in sculpture—through its leaders, political and economic in stature: mayors, capitalists, and presidents; through military figures ranging from the lowliest soldiers to the highest

generals; through portraits of allies and kinsmen from Europe's history and culture; and through personifications of historical events, allegories and figures of Classical Greek and Roman mythology.

The choice of Lincoln, by Coe and many others who made these determinations and backed these commissions, stand out as examples of public sculpture representing American values of patriotism, leadership, and moral conviction. Other choices made during the late nineteenth to early twentieth century in America focused on another part of American history of a darker reality.

Many Confederate statues, monuments, and memorials were placed throughout the United States, viewed at the time of their commissioning and installation by many as symbols of both heritage and history. Some served as tangible marks of both, when placement held a context as either a gravesite marker for Confederate veterans or at the site of a Civil War battlefield. Others were more prominent and purposeful, in their deliberate placement into public spaces—outside municipal buildings, courthouses, city parks, and street squares. By 2016, not counting battlefield or cemetery memorials, a total of 718 monuments and statues still stood around the nation.[4] Prominent among this number were twelve statues of Confederacy figures on public view in the U.S. Capitol Building's Statuary Hall, which have included Confederate President Jefferson Davis and Vice-President Alexander Stephens, as choices made by individual states for representation.

As examples of public artworks that represent shared values, these monuments and memorials were a means for some Americans to carry on the ideals of slavery, inequality, and oppression. That many were installed during the Jim Crow era of segregation speaks to their placement as deliberate visual hallmarks of this era and the failure to deliver on the promise of freedom, which Lincoln himself espoused as president of the North before and during the Civil War, as well as up until his assassination. With the statue of Lincoln created by Waters, we see the possibility of public sculpture as a force for good that has truly been achieved in a visual form.

Waters himself was born on the West Coast, in San Francisco in 1894. He began his studies of art at the Art Students League under Frederick W. Elwell. His travels abroad next led him to Paris, where he learned sculpture from the master, Auguste Rodin; he was the last to have the privilege to do so. After World War I, he worked in London and exhibited there. His early paintings were pastoral scenes—a still life with orchard apples from 1907; another, an oil on canvas piece titled *Cows in a Stream*. His paintings reflected a post-Impressionist style, subdued and not anything like the sculpture he created later in his career. For that, he replied to Rodin to show him the way. The result was that Waters became an accomplished portraitist in the sculpture medium while incorporating a style modeled after Rodin that was expressive, dramatic, and visceral in its presentation of the human figure.

Waters was not the only American sculptor who was profoundly influenced by Rodin. The accomplished American sculptor Lorado Taft, who knew Rodin from his time spent in Paris studying at the École des Beaux-Arts. During his career, Taft produced two pieces that featured Lincoln—a bronze statue *Lincoln, the Young Lawyer* (1927) for Urbana, Illinois, and a large-scale bronze relief that commemorated the seventy-eighth anniversary of the Lincoln–Douglas debate, installed in Washington Park, Quincy, Illinois (1936).

Another sculptor that went on to great acclaim modeling Lincoln on a grand scale was John Gutzon de la Mothe Borglum, who became friends with Rodin in the early 1890s, studying art at the Académie Julian in Paris and (like Taft) at the École des Beaux-Arts. Borglum embraced naturalism that Rodin endorsed as the height of achievement in sculpture, expressed by the shared belief that "to any real artist ... all nature is beautiful, because the eyes, fearlessly accepting all exterior truth, read there, as in a book, all inner truth."[5]

Borglum sculpted both a bronze bust and a colossal head of Lincoln in marble, followed by his masterpiece on Mount Rushmore, South Dakota. Jonah LeRoy "Doane" Robertson, the state historian of South Dakota, had conceived the idea of a new monument featuring the portrait heads of Lincoln and Washington in 1924 after seeing the sculptor's work on the Confederate reliefs at Stone Mountain, Georgia. He invited Borglum to tour the area of the Harney Mountains, to see if such a grand scale carving effort was possible. Borglum was easily convinced to take the project on, with additional portraits of Presidents Thomas Jefferson and Theodore Roosevelt added to the series. Borglum (aided by his son, Lincoln) carved the portraits of the four U.S. presidents from the granite face of the Black Hills in Keystone, South Dakota, from 1927 until his death in 1941.

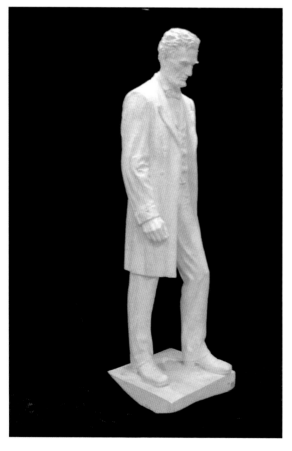

Study for *The President* (1925) in plaster by George Fite Waters. (*Photograph 2020. George Fite Waters Collection. Image courtesy of Joyce Waters Ratliff*)

Waters' initial design for the statue was completed in early 1925, but it was subsequently rejected by Portland's Art Commission "because the portrayal was judged not typical of Abraham Lincoln."[6] More specifically, feedback from the citizens of Portland stated that Lincoln should appear with a beard, which Waters had omitted from his first 32-inch-tall scale model. The controversy helped to establish a clear direction for the sculptor as far as the modeling of the statue and what time period of Lincoln's life should be depicted. The remodeling effort included the beard.

From a photograph dated July 21, 1925, Waters was shown patiently working on the new figure study. Coe was pleased with the result and officially commissioned the sculptor on August 27, 1925. The contract further stipulated that Waters would be paid a total sum of $8,000 for the completed bronze statue.[7]

With Coe's backing in place, the new design was modeled 10 feet tall in clay, being formally approved by the city council on March 24, 1926, under city ordinance no. 54789. Six months later, Waters had created a 10-foot-tall casting mold of the new design in plaster in preparation for the lost-wax casting at the Claude Valsuani foundry in France. Waters presented Lincoln in a dramatic posture—the head slightly bowed, the figure's left foot forward, and wearing a frock coat. The characterization represented Lincoln at the moment of his Gettysburg Address during the Civil War.[8] The time period of Lincoln's appearance was also specified, in advance, by the project's main backer, Coe.

In his choice of posture and characterization, Waters presented his Lincoln as a simple man, without dramatic gesture or flair, but with an air of humility. The statue contrasted greatly with other, earlier sculptures done of Lincoln, such as *Lincoln at Gettysburg* by the sculptor Charles Mulligan in 1903, which showed the president gesturing grandly with his right hand upraised, the head lifted up, and his gaze proud and resolute. The somber visage seen in Waters' statue was more comparable to that seen in Daniel Chester French's *Lincoln at Gettysburg* (1912) or the equally compelling *Lincoln at the Second Inaugural* by George Ganiere (1913), both sculptures that had the head of the figure bowed and hands clasped either in the front (French) or behind the back (Ganiere).

Waters incorporated other details for historical accuracy and realism in his Lincoln statue. He included the use of two "death masks" of the sixteenth U.S. president for the portrait of the statue, and the use of a period coat was obtained from Washington, D.C. for the modeling of the figure's clothing.[9]

To emphasize realism in the design, the sculptor also used a live model, an English accountant who was visiting Paris, to pose for the statue, owing to the fact that the man was the same 6 feet 4 inches in height as Lincoln, along with other body measurements and proportions to match.

The location of the new statue was predestined by Coe and his earlier donations of statuary, with the statue allocated a space in the block bordered by Main and Madison Streets in the South Park Blocks (thereafter called Lincoln Square). It took nearly a year for the city council to finalize the location by June 1928.

The bronze casting was done in early 1927, with a formal review of the new statue offered by Waters in his Paris studio to art critics and reporters alike on February 12, 1927 (Lincoln's birthday). Formally titled *The President*, the statue weighed nearly 1 ton; it was done in a style reflective of the sculptor's former teachings under Rodin—the face lined in great detail, capturing the moment when Lincoln offered reviewed his Union troops on the brink of either victory or defeat on November 19, 1863.

George Fite Waters working on the 10-foot-tall clay model of *The President* in Paris, France. (*Photograph 1925 by J. Roseman. George Fite Waters Papers. Image courtesy of Joyce Waters Ratliff*)

Records of the sculptor show that the bronze statue of Lincoln was shipped aboard the SS *Zenon* from the port of Havre, France, on February 23, 1927. The shipping manifest from American Express Company listed Dr. Henry Waldo Coe in Portland, Oregon, as the recipient.

While the plan was to have *The President* in Portland for an unveiling in April that year, it was not until June 20, 1928, that the city formally accepted the donation of the statue. Another four months would pass after that before it was formally unveiled to the public on October 5, 1928.

Part of the delay in the Lincoln statue's arrival to Portland may be attributed to the demise of its lead benefactor. The "giver of statues," Dr. Henry Waldo Coe, died on February 15, 1927, in Glendale, California, just three days after the Paris studio unveiling of the Lincoln statue.[10] To see his legacy in public sculpture through to completion, his son, Wayne Coe, carried on discussions with the city council and mayor's office. He was aided in these efforts by Dr. William Wallace Youngson, a longtime friend of the late Dr. Coe.

The Lincoln statue was installed upon a 4-foot-high marble pedestal as agreed to by the city, facing north. As a result of additional council planning efforts, it was also situated across from a Masonic Temple (Lincoln had been a Mason in his life), furthering the statue's community connections with respect to its location as a public artwork.

Shipping invoice for the bronze statue *The President*, February 23, 1927, from Havre, France to Portland, OR. (*George Fite Waters Papers. Image courtesy of Joyce Waters Ratliff*)

These connections between the identity of the statue and its meaning to veterans were evident in the dedication ceremony that fall. Among those groups that attended were members of the Grand Army of the Republic (GAR), including William Clemmens, the Department of Oregon GAR commander, who unveiled the statue from its American flag. Other attendees—such as William Verry, principal of Lincoln high school, Rabbi Henry Berkowitz, Reverend E. C. Farnham, and Madame Leah Leaska—offered supportive remarks in honor of the day and its historic figure. The Sons of Veterans, Woman's Relief Corps, Daughters of Union Veterans of the Civil War, and Ladies of the GAR also assembled to see the latest addition to Portland's sculpture.

The day also saw Coe's family witness the fruit of their patron's labors, which was not soon to be forgotten.

There is a significance in Waters' ability to complete a commission from his studio afar from Portland over a period of almost three years. It was not unheard of for a public sculpture commission of this size and scale, but it is one that can be counted as successful in many respects, cementing his reputation as a sculptor both in the United States and France.

Like Alonzo Lewis, another American sculptor who had modeled Lincoln for public statuary on a grand scale, Waters was accomplished at carrying on several sculpting commissions simultaneously. While he was engaged in creating the first Lincoln design in 1925, he had hosted William Thomas Cosgrave of Ireland in his Paris studio as a live model for a new portrait bust undertaken in February that same year.

Among the terms of the agreement Waters signed with Coe in 1925 was a stipulation that the Lincoln statue in bronze for Portland was to be one-of-a-kind, never copied or duplicated. The statue on view today is truly unique in that there are no others of its kind in other collections or public displays.

The Lincoln statue in Portland was not the last statue of the Civil War era that Waters completed. Between 1933 to 1935, he finished a full-figure statue in bronze of John Brown, an abolitionist who led the executions of five farmers who were slave owners in Kansas in 1856 in an incident later known as "Bleeding Kansas." Brown is credited for leading a force of thirty Free State fighters in August 1856 against 250 pro-slavery militia at the Battle of Osawatomie. The statue was cast by the Borbedine foundry in Paris and installed at Osawatomie, Kansas.

The Lincoln and Brown statues by Waters represent just two of many examples in the ongoing conversations about war memorials, military figures, and historical events personified through public monuments and sculpture.

The future of Portland's public sculpture scene was changing even in Coe and Waters' time. New directions, visions, and supporters would come forward regarding how sculpture would play a part in the city's emerging landscape.

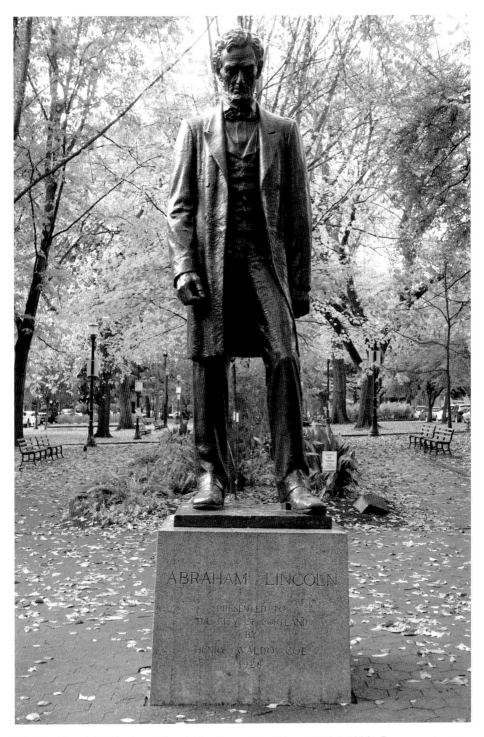

The President (alt. *Abraham Lincoln*) by George Fite Waters (1926–1928). Bronze-cast statue, Portland, OR. Photograph 2017.

6

OLIVER L. BARRETT
(1892–1943)

More than a few of Portland's public sculptures have come from sculptors who lived and worked outside the city or had their statues copied from originals on display in other locations. Some, like Alexander Phimister Proctor and Alice Cooper, had taken up temporary residence only, either to see their public statuary through to completion and installed in Portland or were called to other environments to continue the practice of the sculpture medium for other commissions in other U.S. cities.

One native son who originated from the Pacific Northwest and could accurately be described as a Portland sculptor (or at least, an Oregonian sculptor) was Oliver Laurence Barrett. His odyssey as an artist lasted just fifty years—from his birth on October 8, 1892, to his death on August 7, 1943. During his career as a practicing sculptor, Barrett produced several public memorials and sculptures for Oregon and California. Yet three stand out as distinctive, identified for their qualities of enduring aesthetic beauty, folk hero romance as a dream, and mystery blended with controversy. These were his sculptures for the *Rebecca at the Well* fountain (1926), *Paul Bunyan and Ox* sculpture study (1929), and *Theodore Roosevelt Memorial* sculpture for Battleship Oregon Park (1939), respectively. Each of these sculptures was marked with varying degrees of success.

Barrett was born on October 8, 1892. His early life was spent working in mills and logging camps around the Pacific Northwest, and he also may have spent time as well working the coastal trade, as he was later known as the "seagoing sculptor."[1] He began teaching sculpture at the University of Oregon in Eugene in 1927, a post he would hold for the remainder of his life.

During the 1920s, Barrett was recognized in art exhibitions and commissions as a sculptor who focused on Western themes and as an "interpreter of early Oregon country days."[2] A sampling of the titles and subjects Barrett completed by 1929 support his contemporaries' view of his work in the medium—*Sandstorm*, which showed a cowboy and his steed in the midst of a desert storm, installed at the Legion of Honor palace in San Francisco; another character study, *The Indian*; a group sculpture depicting wild horses; and a religious Christian-themed sculpture, *St. George and the Dragon*.

It is important to note that Barrett's portfolio during the 1920s followed similar styles of Neoclassical rendering of figures, with European and American subjects as the focus. They were dramatically rendered, reflective in their anatomical detail, and poised with balance and positioning as seen in other Beaux-Arts sculptures of the late nineteenth century.

This approach to his work led to one of Barrett's most enduring public sculptures from 1926—a bronze statuette of the Biblical character Rebecca, carrying a vase of water on her shoulder. This sculpture became the centerpiece of a trefoil-style fountain made of sandstone, designed by the architect Carl Linde, and installed in the South Park Blocks of Portland.

Some differing viewpoints exist regarding the construction of the fountain by Linde, namely when and how Barrett's statue of Rebecca entered into the design and its installation. One source placed the bronze sculpture as a later addition by Barrett in 1928, as a replacement for a vase originally planned for the fountain's center. However, the bronze sculpture appears to have been part of the design all along, as a newspaper account described the gift of the fountain to the city of Portland on September 4, 1926, as "about 12 feet high and on a triangular base … Under the decorative arches is a smaller bronze statuette."[3]

The choice of concrete, or cast stone, as the material for the fountain's base, arches, cupola, and drinking platforms was also a source of debate between the designer, Linde, the city council of Portland, and the Portland Art Commission. Opinions varied about the durability of different materials and the cost for each type.

The design proposal for the new fountain was submitted to the city council on December 23, 1925, with a supporting communication from Joseph Shemanski, the patron who was funding the project. A subsequent review by the Art Commission approved both the design and the suggested placement of the fountain (between Southwest Main and Southwest Salmon Streets), but it did not approve the use of cast stone as the material.

The city council overruled the Art Commission and approved the use of cast stone for the fountain's construction to proceed. Their passage of city ordinance no. 49231 on April 7, 1926, served a dual purpose, with acceptance of the fountain as a gift by the city. The decision serves as a clear example of how public sculpture by this time was becoming increasingly a process subject to review (and sometimes disagreement) among public officials.

Weighing in on the controversy, Thayne Logan identified granite as the material first envisioned for the fountain. Logan was a designer who worked for Linde in the 1920s, and he attributed the adoption of cast stone due to its popularity as a new material at the time of the commission. Over time, the material of the fountain has been described as "cast Oregon sandstone," suggesting that native sandstone was used as part of the material's original mixture base.[4]

Barrett certainly had experience with developing figures from Christianity as sculptures in bronze. The choice of Rebecca as the figure for the new fountain, as a figure from the Old Testament of the Bible, visually ties in the function of the fountain as a drinking source offered as a token of city hospitality, to the story of Rebecca bringing water from a well to Abraham's servant.

While Barrett was charged with the execution of the sculpture in bronze, the choice of the figure resided with the patron, Shemanski, an immigrant from Poland,

who arrived in Portland in 1889 and founded the Eastern Outfitting Company. His business interests expanded to offer the Eastern Department Store in downtown Portland. The Shemanskis were also of the Jewish faith; in one article from 1922, they were recognized for their support of the first annual ball of the Portland Menorah Society.

While the personal religious beliefs of the patron are not 100 percent conclusive in the case of the commission for the *Rebecca* statue, there were in place practical relationships nationwide between arts patrons and sculptors commissioned for new sculpture projects. Private commissions—even artworks predetermined or destined to become public displays—were the purview of the patron as far as the subject selected for representation. A sculptor might be afforded flexibility in the artistic interpretation, choice of medium and style (especially when allegorical themes were desired over statues and other sculptures that depicted individuals), but rarely were they given free rein where the principal figure or central element was concerned.

Sculptors in the United States were more like artists for hire with respect to public memorials, monuments, and statuary. This attitude carried up through the early 1940s and was not widely replaced as a practice for public sculpture until the advent of both modern art as a movement and the rise of public agencies, who expanded their control of the review process.

Barrett would certainly have the freedom to create and model his ideal of Rebecca for the new fountain. Yet to think that it was Barrett who determined the choice from the start is to ignore the predisposed nature of public sculpture as a function of commissioned work up to this point.

Adding to the connective history between Barrett and Shemanski was a shared love of animals. The fountain was equipped with two lower basins supplied with water, each one low enough to the ground so that dogs could easily drink from these. Logan recalled how Shemanski "wanted something for the little animals."[5] Barrett was likewise noted for his lifelong affinity for animals: "Known as a friend to every stray dog and cat … shown in much of his work, as well as his understanding of the nature and structure of animals."[6] As a public drinking source, the new fountain represented a transition away from serving horses with a water supply (as intended for earlier fountains like the *Skidmore Fountain*, and *Thompson Elk Fountain*) to providing drinking water for pets, and more specifically, dogs.

At the dedication ceremony on September 4, 1926, Shemanski was joined by commissioner Charles A. Bigelow, acting mayor in the absence of mayor George Luis Baker, who accepted the gift of the fountain on behalf of Portland. Shemanski talked about how his gratitude to Portland had inspired the gift, and how the fountain could carry this forward to others in the future:

> I do so with gratitude for the many happy years that have been granted me to live here—and for the sincere friendships that it has been my privilege to enjoy because of my residence here. When I came to this hospitable city, alone and a stranger, I was given a warm welcome. Accept it, rather, as a symbol of hospitality and of welcome from our citizens to strangers, who now and in future years will find courage in the fine spirit of friendliness for which Portlanders are known wherever knowledge of our Rose City has spread.[7]

66

In an example of how elements of a public sculpture sometimes took on odd ownership, where future care and responsibility were at stake, the statue *Rebecca at the Well* became part of the city of Portland and Multnomah County public art collection. The sandstone-cast fountain was the responsibility of the Portland Water Bureau. An inventory in 1968 revealed that the fountain "was found to be in the worst condition out of all those inventoried."[8] Since that time, the fountain has been repaired twice: in 1987–1988 and again in 2004.

For Barrett, the successful completion of the bronze Rebecca helped to support his becoming a new associate professor of sculpture at the University of Oregon in the following year. In short order, the sculptor looked to his own personal history and artistic desires for a new sculpture that he envisioned on a grand scale.

Barrett's early life working in the logging camps of the Pacific Northwest offered a familiarity with the folklore and traditions of that labor group. One of the chief mythos figures that defined the lumberjack personae was Paul Bunyan and Babe the Blue Ox.

Barrett produced at least three sculptures with Bunyan and the ox during his career. The first was done as a study only in modeling clay, as a model for what the sculptor envisioned as a larger public monument, made from stone and "in gigantic size,

Shemanski Fountain by Carl Linde and Oliver L. Barrett (1926), located at South Park Blocks between SW Main and SW Salmon Streets. Photograph 1968. (*City of Portland Archives & Records Center*)

Rebecca at the Well by Oliver L. Barrett (1926). Bronze-cast statue, Portland, OR. (*Photograph 2018 by Fred F. Poyner IV*)

perhaps 20 feet high."[9] The study, completed in the fall of 1929, showed Paul kneeling at the head of the ox on the left side, while the ox almost completely obscures the human figure when viewed from the right. The composition and style appeared as a presentation modeled after antiquity, reflecting a Neoclassical approach by the sculptor to the nineteenth-century folk hero. The ox could easily be seen as a manifestation of the Cretan Bull from Greek mythology, while the semi-nude, muscular figure of Bunyan, portraying Hercules and his heroic identity.

An interview with Barrett after his completion of this sculpture outlined the sculptor's intentions to see it made into a more permanent display. The outlook was one tinged with a sense of romanticism coupled with an optimistic view of what Bunyan meant as a figure of regional identity:

> It is the hope of Mr. Barrett that the statue may some day [*sic*.] become the symbol of the Northwest basic industry, lumber, and that its replica it towering size may be placed in some prominent place as a fitting memorial for this spirit that is so familiar and so loved by all lumbermen.[10]

Barrett continued to refine his concept for a monumental statue of Paul Bunyan. This second version of the statue was completed by 1931, and while it maintained the same basic positioning of Bunyan on the left side, notable changes were made in the design. The figure of Bunyan was now shown standing erect, his left hand resting on top of a lumberjack's ax hilt, the right arm draped over the back of Babe the Ox. This presentation still captures a classical feel as well, with the bowed head of the ox continued as a detail and Bunyan seen as shirtless and bearded. The figure has a posture that is ramrod straight, but unlike the earlier version from 1929, he is visible from the mid-torso and up when viewed from the right side.

The 1931 study was also envisioned by Barrett as a larger display: over 35 feet in height.[11] However, no official endorsement from the University of Oregon for a new commission to create the larger version was forthcoming, nor was Barrett able to identify either a municipality or a private source (such as a lumber company) to sponsor the statue as a new public monument.

Whatever his intended outlook for the statue, the sculptor continued to look to Paul Bunyan and Babe the Blue Ox as a source for creative inspiration. This attitude led Barrett to model a third and arguably the most definitive version of the subject as a sculptural piece.

By 1933, artists across the country were able to receive support from a variety of "New Deal" programs that were initiated under President Franklin Roosevelt to get the country back on its economic feet during the Great Depression. Under the Works Progress Administration (WPA), a federal agency that administered these labor-oriented programs, artists were able to gain employment by creating artwork through the Federal Art Project. This was seen as a great success and resulted in public art projects nationwide, ranging from mural paintings and architectural work, to sculpture and mixed media artworks.

By November 1, 1936, a total of 5,219 artists were employed through the Federal Art Project, with 49 percent represented in the Fine Arts (murals, sculpture, easel, and graphic art); 29 percent in the Practical Arts (poster and applied arts, photography,

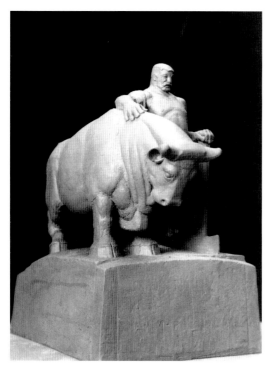

Above: Oliver Barrett working on study for *Paul Bunyan and Babe the Blue Ox* (1931). Art Department, University of Oregon, Eugene. (*Photograph 1931 by George H. Godfrey. University of Oregon Libraries*)

Left: Study for *Paul Bunyan and Babe the Blue Ox* by Oliver L. Barrett (1929). (*Photograph 1935 by Kennell-Ellis. University of Oregon Libraries*)

design, arts and crafts, stage sets); 16 percent in education; and 6 percent in "technical and coordinating."[12]

Barrett was among those artists included in the 1934 report for the Federal Art Project, representing the University of Oregon in Eugene (Portland alone listed eighty other artists). For his contribution, not only was Barrett considered an arts educator for his role as a sculptor instructor at the University of Oregon, but he also created a new sculpture in terra-cotta of his recurrent subject, Paul Bunyan.

The small statuette was a little less than 1 foot high, showing a bearded figure wearing a t-shirt and lumberjack's cap, an ax handle in the right hand while the head of a blue-colored ox curls around the front of the figure's midsection from the left side. The composition almost appears as if Bunyan is holding a shield, in the shape of an ox head, which is generalized to the point of abstraction.

This third version of Paul Bunyan demonstrated how Barrett by this time was incorporating new ideas about modern art and abstraction as international influences on sculpture. The figure was still identifiable, yet rendered in such a way that it marked a clear transition away from the earlier designs of Neoclassical construction.

Barrett received peer recognition for his Paul Bunyan-themed sculptures, when in 1937, Joseph Danysh, the San Francisco regional director for Federal Art Projects, visited the University of Oregon and reviewed several artworks produced by the University's Art School. Among his comments, Danysh suggested that Barrett's sculpture titled *Paul Bunyan and the Blue Ox* should be enlarged for display and placed in the Pacific Northwest "where it would attract [the] interest of art lovers from all over the world."[13] The sculpture referenced was almost certainly one of the two earlier studies Barrett did on the subject from either 1929 or 1931, respectively. Danysh's favorable opinion of the sculpture was considered high praise at the time, given his experience as an art gallery owner, a graduate from the fine arts program at the University of California, and his role as the director for the WPA's arts-focused program on the West Coast.

The Paul Bunyan terracotta statuette was offered as part of a comprehensive retrospective of the sculptor's work held at the Metropolitan Museum of Art in 1945. It eventually came into the permanent collection of the Jordan Schnitzer Museum of Art, located today on the University of Oregon's campus. It represents the most lasting and tangible example of the sculptor's fascination with the Paul Bunyan character, albeit one that did not become a public sculpture as originally envisioned.

However, a monumental statue of the figure (not by Barrett) was eventually placed within Portland's city borders. This was the 31-foot-high concrete and metal statue of Bunyan installed in 1959 at the intersection of North Interstate Avenue and U.S. Route 99. The occasion was coordinated as part of the Centennial of Oregon's statehood. The characterization of Bunyan in this work was a far cry from the earlier compositions produced by Barrett over the two previous decades. The design omitted Babe the Blue Ox entirely, with Bunyan's hands resting over the top of a double-bit ax blade positioned handle down in front of the figure. The bearded face wears a cartoonish grin, with the towering giant decked out in work boots, blue jeans, and a red-and-white checkered shirt. The colossal Bunyan displays a design and fabrication rendered in such a way as to make the statue appear as more of a novelty or kitsch attraction, rather than a public sculpture. It was certainly a timely fit as far as the emerging Pop Art movement of the 1950s, where artists relied upon comic book-like imagery, brash color

combinations, and nonsensible juxtaposition of figures, words, and scenes to portray a wide variety of cultural themes and icons.

Barrett's third major sculpture of his career did receive recognition as a public memorial and artwork. While this sculpture was indeed a commissioned piece for public display, it differed greatly from the sculptor's earlier works, including the *Rebecca* fountain statue and Bunyan series, both in its final size and artistic style. This was the *Theodore Roosevelt Memorial* for the Battleship Oregon Park in Portland.

The commission for a new sculpture with Roosevelt as the central focus initially appeared similar in many respects to the one Barrett had undertaken for the Shemanski fountain. The commission was led by Jay H. Upton, an attorney from Bend, Oregon, and the department commander of the United Spanish War Veterans. Details emerged in 1938 about the new sculpture, which was designed as a new permanent memorial located south of the Hawthorne Bridge near the entrance to Battleship Oregon Park:

> The spirit of courage, determination and audacity that accompanied the battleship *Oregon* on its historic dash and that inspired Theodore Roosevelt and his gallant men in the Spanish-American war will be portrayed in a heroic statue ... it will be a symbolic, robed figure, holding a sword ... on one side will be a portrait of the great Roosevelt.[14]

The modeling of a U.S. Navy memorial sculpture, combined with portraiture elements and the identity of an equally well-known figure from the same historical campaign (Roosevelt), presented a new challenge for Barrett as a sculptor. From the start, he was faced with portraying the "spirit" of the battleship USS *Oregon* and its exploits, while simultaneously offering homage to one of its greatest American military leaders of the time. Barrett chose to combine artistic styles to render these competing identities, within the same monumental sculpture that reached 18 feet high. For his material, Barrett selected native tufa sandstone that could be quarried from deposits near Brownsville, Oregon.

Aside from his previous work on the Shemanski fountain, Barrett had little practical experience working on public sculpture commissions. This, unfortunately, may have contributed to the outcome of his final work on the Roosevelt memorial for the park, which when completed offered viewers a memorial that was undefined at best, or an artistic representation that sought to promote Futurism's fascist-aligned ideology at worst.

For his large central figure, Barrett chose to model a block figure whose legs became merged with the raised throne-like platform. Its head was male but presented in a style that invoked the Futurist art movement style popular at this time as an Italian convention. Futurism as an artistic style was closely aligned with the historical rise of Fascism, which at this time was espoused by dictators in Europe, notably Benito Mussolini in Italy.

It may also be that the influence of Futurism on the "Colossus of Portland," as Barrett's sculpture came to be known, was an outcome of a larger process among American artists at this time. The rise of artistic expressionism was recognized even then, as seen in a review made by the WPA of artists working in Portland in 1939:

It must be admitted that the native conservatism of Oregonians has, until recent years, materially hindered experimentation and free expression among its artists. Today this restraining influence seems, happily, to be on the wane. Many artists, their viewpoints broadened by a realization of the social significance and the functional usages of art, are creating with broader regional meaning and wider universality.[15]

Once we accept the possibility that Barrett was looking to incorporate an expanded worldview of art—its styles, time periods, and movements—beyond what he had focused on up to this point in his own sculpture (predominantly rendered in a Neoclassical style, using figures from antiquity as guides), then the Roosevelt colossus is seen in an entirely new light.

The head of Barrett's figure, for example, has similar designs to the appearance of figures seen in Pre-Columbian art or stone Mayan sculptures. The rough-hewn, squared-off appearance of the figure's shoulders and head bears a marked semblance to those found on Easter Island, themselves large stone figures that have blank expressions like the one seen in Barrett's work. The presentation of the sculpture as part of a throne or chair gives a North American continental rendition of the Colossi of Memnon in Luxor, Egypt, which dates back to 1350 BCE. The posture of the Portland memorial can be readily seen in other sculptures from Greek antiquity, including *Lady of Auxerre*, made with her left arm hanging straight down at the side, with the right hand over the breast.

What the main statue did not portray was a realistic presentation of President Roosevelt. To meet the conditions of the commission, Barrett modeled a realistic profile portrait of Roosevelt on the left side of the sculpture. The base bore not a dedication to USS *Oregon*, but rather one specific to Roosevelt, as a quote from a speech he made in 1894: "Our nation holds in its hands the fate of the coming years."

While Barrett may have succeeded on the face, in meeting the duality of constructing a memorial that was both allegorical and figurative at the same time, the end result that was produced as a lasting public sculpture was questionable.

The public's reaction to the unveiled work in February 1939 was mixed. Many of the veterans did not appreciate the sculptor's rendition of the memorial, either as a maritime memorial or a tribute to Roosevelt, and that "on a whole they didn't think too highly of the memorial as art."[16] By September 1941, there were calls made for the Roosevelt memorial's removal. Among the most vocal was E. C. Sammons, chairman of the Battleship Oregon Memorial Fund Association. By comparison and Sammons' logic, the *Skidmore Fountain* would be an ideal replacement for the memorial. Sammons even went so far as to elicit the support of famed American sculptor Lorado Taft for his support of an envisioned switch, but to no avail. The *Skidmore Fountain* remained in place.

The point became moot just one year later. With the anticipated construction of Harbor Drive scheduled to begin in early 1942, city workers were tasked with cutting the memorial sculpture into pieces and transporting it across the Willamette River for temporary storage at the city's Stanton Yard. What actually happened to the sculpture is a mystery. One property control officer, Don Eckton, recalled in a 1972 interview that the process of removal may have inadvertently led to its demise: "I think I remember it cracked when they were taking it apart … It wouldn't surprise me a bit if it isn't underneath that highway [Harbor Drive]."[17]

Theodore Roosevelt Memorial by Oliver L. Barrett (1939). Battleship Oregon Park, Portland, OR.
Photograph, *c.* 1939. (*The Oregonian*)

The park where Barrett's colossus once stood is today renamed the Tom McCall Waterfront Park. Both the prominence of USS *Oregon* and Theodore Roosevelt as a historical figure were lessened even in Barrett's time, once America entered the next world war under another president named Roosevelt. For Barrett, the pursuit of sculpture as a passion and profession came to an end just a year after the disappearance of his last public monument. He died on August 7, 1943, at the age of fifty.

Every artist seeks to leave some sort of legacy in their lifetime, with the hope that this will follow after their end. For Barrett, this meant final recognition of his work not just in the public sculpture of the *Rebecca* fountain, but in the breadth of his portfolio of work spanning more than two decades. His portraiture sculpture pursued late in his career marked a fitting conclusion to this scope: busts of prominent Oregonians W. R. B. Wilcox and Levi Pennington as well as experimental sculptures in plastic modeling material focused on general themes, titled *Weight Lifter*, *Primitive*, and *Horse*.

A final lasting tribute by the sculptor may be found today at the Prince Lucien Campbell Memorial Courtyard on the grounds of the University of Oregon, where Barrett taught others sculpture for many years. A pair of kneeling figures in stone, abstracted in their geometric presentation but notable for their matching roles as musicians—hence the title, *Pans*—are posed facing each other at the head of a tranquil reflecting pool. The slightly bowed heads meet the pan flutes each holds, with the whole of the composition radiating peace and harmony in its garden-like setting. The pair play a silent duet, an echo of what one sculptor may accomplish if they have the time and the patience.

7

ROBERT TAIT MCKENZIE
(1867–1938)

Robert Tait McKenzie was a specific type of twentieth-century sculptor. Within the ranks of those who practiced the medium, there existed a subset of those who counted sculpture as one of their many other pursuits, talents, and interests in life. That is not to say that individuals who engaged in sculpture as a sole pursuit and profession were any less accomplished or successful, only that McKenzie was a type of person who excelled at many varied roles during his lifetime, including the fine arts. His repertoire ranged from gymnast to surgeon, soldier, teacher, and philanthropist, with numismatics, painting, and sculpture all activities within his wheelhouse as an artist.

McKenzie was born in Mississippi Mills, Lanark County, Ontario, Canada, on May 26, 1867. His family was Scottish by heritage, and his pastoral upbringing as a youth prepared him for later exploits as a young athlete on the sports field. He enrolled at McGill University in 1885. At McGill, he competed in a wide range of sports and excelled at these, whether it was gymnastics and football, running the hurdles, or other specialties such as swimming and fencing. He became an intercollegiate champion, when he established a record in the high jump of 5 feet 9 inches, and in 1889, he won the Wickstead gold medal for gymnastics. Sports would remain a lifelong passion.

In his academic training as a surgeon, with its requisite knowledge of human anatomy, McKenzie had advanced formal training that later helped him as a sculptor. Anatomy was considered a "must-have" for many artists who underwent training in another established sculptor's studio or took classes in sculpture as a medium at fine-art schools and university programs. While he did not attend formal art schools or instruction, he was trained in anatomy as part of his education in medicine.

McKenzie graduated from McGill, completing his studies in 1892 with honors. This academic training led him to start his own medical practice in Montreal and as a teacher of anatomy at McGill. His belief in physical exams as a means to identify and treat medical conditions in advance was encouraged by the university, leading to his appointment in 1898 as the first medical director of physical training there.

The academic training and professional experiences in medicine offered McKenzie a solid basis for his pursuit of art as a pastime. The subjects of many of his earliest

watercolor paintings (his first medium of practice) were, unsurprisingly, athletes that he observed at McGill. These sketches were accomplished whenever something caught his eye and would be quickly rendered in a notebook McKenzie carried around with him as a constant companion.[1]

McKenzie's passion for both sports and the human body not only directed his medical career, but also served as a primary source of inspiration for his artwork from the onset. His earliest sculpture work was a series of life masks that detailed the musculature of the face done around 1900. Each showed a state of human endurance, with titles to match: *Violent Effort*, *Breathlessness*, *Fatigue*, and *Exhaustion*. For his first small sculpture, McKenzie modeled an athlete in motion—*The Sprinter*—which incorporated physical measurements and studies of several McGill student athletes as part of its design. Another statuette—*The Athlete*—demonstrated the sculptor's potential to meld proportion with intuition when modeling the human figure.

McKenzie was assisted in these early efforts in the sculpture medium by the Canadian sculptor George W. Hill, who was also a friend, and Louis Phillippe Hébert, another Canadian artist who specialized in religious folk-art and wood carving. Both of these artists influenced McKenzie to develop his own personal style that blended realism with the more impersonal Beaux-Arts monumental style prevalent in many European and American artworks of the era.

In 1904, McKenzie traveled to Paris to spend the summer in an artist's colony. It afforded him the opportunity to also see his *Athlete* on view at the Royal Academy in London. On June 10, he sailed to France from England, where he met several others whose friendship and work alike made a lasting impression on him as a sculptor: the American sculptors Paul Bartlett and Richard E. Brooks and the Canadian painter Wilson Morrice. Brooks especially encouraged the young sculptor and made an impression:

> He is one of the best fellows here … happy, good-natured and cosmopolitan. He knows all the people in this quarter by their first name, has a fund of good stories … yet works seriously. He is in the same court and is good to me in advising and helping me in my work. He is well-known in Boston by his bust of Oliver Wendell Holmes.[2]

McKenzie was also able to see another of his initial athlete-themed sculptures, *The Sprinter*, included at the Paris Salon during his time in the city.

Following his return home, the sculptor continued his efforts to portray athletes of the highest caliber, ranging from swimmers and divers to throwers, jumpers, skaters, runners, and hurdlers. In 1912, he designed a 46-inch-diameter medallion in plaster that showed three hurdlers in motion, titled *Joy of Effort*. It was exhibited at the 1912 Olympic Games in Stockholm, Sweden, as part of the American section of the International Olympic Committee in commemoration of the Olympiad. Following the conclusion of the Fifth Olympic Summer Games, it was cast into bronze and permanently set into the wall beside the stadium entrance. McKenzie was recognized for this artwork by King Gustaf V of Sweden, who awarded him a silver medal in 1914.

McKenzie found a recurrent theme both in athletes and the Olympic Games in his numismatic work and also sculpture. Beginning with the St. Louis Summer Olympics in 1904, he attended all but one of the Olympics held during his lifetime. In 1936, the sculptor was accorded a high honor, when he was invited to design the 1936 medal for

the Society of American Medalists. His finished design—titled with the Biblical injunction *Rejoice Oh Young Man in Thy Youth*—pictured a shotput Olympian on one side, with a series of four runners on the reverse. The Medallic Art Company cast the medals, one of which is found today in the collection of the Smithsonian American Art Museum.

McKenzie also captured the figure of 1936 Olympian Jesse Owens in a sprinter's stance, based on earlier observations of the athlete during Owens' competition at the Pennsylvania Relays that same year. The 9-inch-high plaster study was accurate down to the placement of the runner's feet, as McKenzie recorded in his studies of the subject:

> I was attracted by the pose he [Owens] took before starting his run for the broad jump—Not with his feet together but resting on his left and ready to push off with the right slightly crouched head raised—and arms hanging semi relaxed [*sic.*]. He stood in this pose for some time concentrating his mind on the effort he was about to make. Most runners start with their feet together but not Owens ... I made sketches in pencil on the spot front and side to get the balance of the figure and made the hasty model in clay the same night after the Relay Games while the impression was vivid.[3]

Following his return to the states in 1904, McKenzie had a major shift in his life when he accepted the newly created position of director of physical education at the University of Pennsylvania. It provided him an opportunity to "develop, test and implement his theories on health and athletics" with much of this work based upon his own experiences as an athlete at McGill and efforts to develop programs of physical exercise as a method to prevent disease.[4]

Among the roles McKenzie championed following his relocation to the United States from Canada was his advocacy for a newly formed organization geared toward helping

Rejoice Oh Young Man in Thy Youth by R. (Robert) Tait McKenzie (1936). Bronze-cast medallion. (*Smithsonian American Art Museum*)

boys excel in the outdoors. The sculptor met and became friends with Sir Robert Baden-Powell, who had introduced the concept of "scouting" to America after founding the movement in Great Britain in 1908. Not only did the two men share a desire to see youth advance through scouting, but McKenzie included observations made by Powell during early training in "the art of scouting, woodcraft, teaching them observations of the birds and beasts, the management of boats, canoes, camping outfit, ropes and [fire] arms."[5] McKenzie incorporated these studies into his comprehensive book *Exercise in Education and Medicine*, published in 1909 by the W. B. Saunders Company of Philadelphia.

In 1910, the Boy Scouts of America (BSA) was officially founded in the United States. Local councils (including the first one in Philadelphia) were established to serve local Boy Scout Troops with youthful members who ranged in age from eleven to eighteen. Over the next 110 years, almost 110 million Americans participated in scouting at some time in their lives. One year after its founding, the BSA produced its first edition *Boy Scouts Handbook* as a guide for newly enrolled boys and adult leaders.

McKenzie was soon active in Philadelphia, helping to organize the first chapter of Boy Scouts in the city and was one of the founding members of the Philadelphia Executive Council for the chapter in 1911. Through his efforts of support, McKenzie became a "Scouter"—a term that would apply to those who were devoted to the Boy Scouts and its mission to promote the character, citizenship, and welfare of boys across America.[6] He remained active as a member of the council for the rest of his life.

McKenzie was remarkable not only in bringing his expertise in physical training to the Scouts and its new organization, but for also lending his sculptural talents to its cause. He described the moment when the idea and need for a power symbol of the scouting movement was raised, clearly in the minds of some regarding him as the instrument of its fulfillment:

> Dr. Charles Hart suggested that there should be something tangible which could be placed before the eyes to represent the product of this altruistic organization, something that would stand as a symbol for what Scouting stood for, in fact a statuette of the "Ideal Boy Scout" and in saying this, he pointed his finger at me. Knowing Dr. Hart as I did, and with characteristic vigor that marks everything he does, he arranged for a series of parades to enable me to choose a suitable model. The competition narrowed to three; finally, Asa Franklin Williamson Hooven was selected as having the most points. The resulting statuette fixed for all time, his fine face and boyish figure at 12 years of age.[7]

The design by McKenzie for his Boy Scout figure resulted in a statuette 18 inches in height, titled *The Boy Scout*. In addition to the twelve-year-old Hooven, the sculptor had another scout, G. Dunbar Shewell, also model for the design. The scout wore the uniform of the era, complete with shorts to the knee, boots, knee-high socks, a long-sleeved uniform shirt with neckerchief. In the figure's right hand, a brimmed hat was held, the left hand resting on the hip, with a hatchet hanging from the belt on that side. The young boy's head is tilted to the right, with the body posed at easy rest. The base of the statuette displayed the scouting emblem with the words of the Scout Law legible around the base. Most of the modeling work was done at McKenzie's studio in Marion, Massachusetts.

On March 10, 1911, McKenzie presented his design to the Philadelphia Council Executive Board. The occasion marked the foresight of the sculptor, in his belief that his version of a Boy Scout visually embodied the principles of the organization as one dedicated to America's youth and would also endure over time as a hallmark of the Boy Scouts of America. McKenzie backed up this belief, by taking the unusual step of donating his copyright to the statuette design entirely to the Boy Scouts for use in perpetuity.

The sculptor delivered remarks about the design at the time of its donation, which reflected his passion for the movement and belief in its mission to promote the morale, character development, and engagement of boys with the help of the scouting organization:

> He trusts that his uncovered head may betoken them to reverence, obedience to proper authority, the well-ordered discipline so necessary to our well-being as a nation; that the hatchet, on which his hand rests, may serve as a symbol of truthfulness that characterized him who first sat in the chair of state in this the birthplace of national freedom in America; that he may never unsheathe it for grinding purposes; that he may never raise it in the cause of wanton destruction, but always for the defense of the weak and for hewing out new and nobler standards of conduct and progress; that he may apply it unceasingly to the neck of treachery, treason, cowardice, discourtesy, dishonesty and dirt.[8]

McKenzie's largesse notwithstanding, only ten copies of the statuette were cast into bronze, with the majority of these going to those council members who had donated $100 each to offset the mold and casting process. According to Dr. Charles D. Hart, council president, no more of these bronze models were ever to be cast, with each copy numbered and the name of the person to whom it was given stamped in the base. Among those to receive numbered copies were Calvin Coolidge and Baden-Powell.

The design soon proved to be too popular among Scouters to be a limited edition. Plaster copies in the 18-inch size were offered by the National Council of the BSA for public purchase, in green, bronze, and ivory finish starting in 1917. These were followed by a limited-edition series of more finished statuettes, 8 inches in size, produced with either a bronze or silver metallic cast by the Medallic Art Company beginning in 1934.

However, the scouting leadership in Philadelphia had bigger plans in mind for the original design. In 1914, McKenzie was tasked to create another design, based upon his earlier one, for a larger-than-life, monumental statue of a Boy Scout in bronze. McKenzie's work on the new design was interrupted when he left in the following year to go overseas and support the war effort. It proved to be a long hiatus, as far as the prospect of a larger scout statue being done.

In early 1915, accompanied by his wife, Ethel, McKenzie journeyed to England, intent on serving in the British Army. The couple took up residence at an old mansion called Deerstad House in nearby St. John. His background as a physician, surgeon, and physical fitness expert led to his being commissioned as a lieutenant in the Royal Army Medical Corps. Among McKenzie's duties, he was responsible for developing a physical training program for new soldier recruits and their training camps throughout Scotland and England. Equally important, he worked to aid soldiers with amputees or disfigurement from the war in Europe, by designing new prosthetics. McKenzie's efforts

Above: President Calvin Coolidge receiving a copy of *The Boy Scout* bronze-cast statuette by R. Tait McKenzie (1911). Location shown is outside of the White House, Washington, DC, where Coolidge greeted 1,500 visiting Boy Scouts from NY, NJ, and CT. Photograph 1927. (*National Photo Company Collection, Library of Congress*)

Right: R. Tait McKenzie. Photograph March 20, 1914, Bain News Service. (*George Grantham Bain Collection, Library of Congress*)

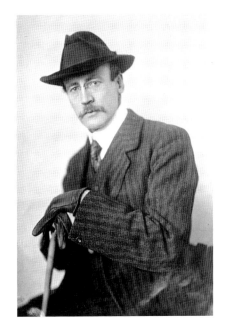

to rehabilitate these soldiers has been credited as having provided a basis for modern physiotherapy practices in use today. His only sculpture completed during the war years was a representation of a young Seaforth Highlander ("Blighty") on leave in France.[9] The armistice of World War I saw his safe return to the United States, and he returned to his old job at the University of Pennsylvania, where he continued to teach until 1929. He took a one-year leave of absence, and upon his return in 1931, he was appointed the J. William White research professor of physical education, the first appointment of its kind at the university.

Seven more years passed until McKenzie again took up the modeling of the Boy Scout statue, which was first envisioned in 1914. The effort was reinitiated with the selection of new models for the statue: P. Douglas Shannon modeled the head of the statue, while Scout Albert Frost was selected to model for the high hiking shoes. Joseph Straub served as a third model. In all, four Boy Scouts from BSA Troops of the Philadelphia Council provided the basis for *The Ideal Scout* (also known as *Ideal Boy Scout* or *The Scout*), which the sculptor unveiled in 1937.

Differences between the 1911 design and the new 1937 design were kept to a minimum by the sculptor. The new statue was larger than life-sized, of course; other details were more subtle in the new figure of the Boy Scout. For instance, the haft end of the hatchet now sported a deer's hoof, copied after a custom hatchet McKenzie had seen used by a Canadian guide. New scouting insignia developed since 1911—such as the Troop number "1" on the left sleeve—were also added to the uniform. More importantly, major elements went unchanged between the two versions, including the pose and the realism of features modeled after actual Boy Scouts, both imbued with a youthful appearance and a natural pose of relaxation.

McKenzie's astute knowledge of anatomy also shaped another modeling approach important in the 1937 statue design; he purposely made the boy's head and feet slightly larger in proportion to the rest of the body, as a sign of adolescent development commonly seen in youths of the age depicted.

Like his first model for the statuette, McKenzie devoted the design of the new statue to the Boy Scouts of America as the holder of the copyright, with the understanding that copies of the statue were to be made available to any community that wished to buy one, providing that it was properly erected and suitably landscaped.[10] The first cast in bronze was made at the Bedi Rasey foundry, unveiled in a public dedication ceremony where it was installed in front of the newly constructed Philadelphia Council headquarters on June 12, 1937. Bedi Rasey cast seven additional copies of the statue that year, with one more done in 1941 and installed in Ottawa, Illinois, at the gravesite of W. B. Boyce, the founder of scouting in the United States.

The passage of time has made a remarkable statue all the more noteworthy as a sculptural effort by McKenzie. In the first sense, there is a substantial pause between his creation of the first, smaller design in 1911, followed by a second, larger, but nearly identical design of a Boy Scout, completed in 1937. The success of both versions may be attributed both to McKenzie's role as an advocate of the organization and talent in rendering physical youths in the prime of their lives. It is also a testimony to the Boy Scouts as well, in its immediate popularity as a new organization geared towards the welfare and character development of America's male youth beginning in the early twentieth century.

A second time factor that has become evident with *The Ideal Scout* as a widespread public sculpture links back to the vision McKenzie shared with many other Scouters, in how the artwork may afford a vital and tangible visual connection to the history and identity of the scouting movement. This factor was realized in the passage of decades since 1937, where a total of forty-two statues have been placed throughout the United States, and an additional three more internationally were installed over the past eighty-three years to today.

These orders for new bronze casts of McKenzie's statues had come in waves over the decades. Following the initial run of copies cast by Rasey in 1937, the next statue to appear was commissioned by the Philadelphia Council's Scouts and presented to the National Council Headquarters in New Brunswick, New Jersey, in 1954. The Modern Art Foundry of Long Island produced this casting, and it was responsible for all others that have followed since that time.

The intervening years have led up to 1972, when the Scouters of two West Coast cities sought their own versions of *The Ideal Scout* to publicly represent the BSA's local membership to all who came by their respective council offices. Both in Portland and Seattle, *The Ideal Scout* found a new home and brought a new identity, prideful with tradition and dedication to youth, as consistent a theme in the 1970s as it had been in McKenzie's own time.

In another example of how *Ideal Boy Scout* has continued to remain a part of the scouting movement over time, it is noteworthy that many of the statues added after 1954 have accompanied new BSA construction projects for council buildings and centers. Portland's copy of *Ideal Boy Scout* falls into this category, with its commemoration as part of the new Columbia Pacific Council's Service Center expansion in 1972. Another bronze copy followed for the new Walter and Olive Stiemke Scout Service Center in Milwaukee, Wisconsin, in 1985.

The Ideal Scout represents a public sculpture where a sculptor may be recognized for true greatness. It is in the melding of artistic vision, with a meaningful message and identity, where values are shared by members and cherished for their ability to convey a history, a benefit to society, and a passion for educating youth through a sculptural medium that defines truly great public art.

While McKenzie's presentation of a young scout was exceptionally rendered, accurate, and engaging for viewers, part of its success in terms of this "longevity" was tied to the foundations of the Boy Scouts of America itself as an organization. It has continued since starting in America in 1910 up to the present day; it has weathered changes in American society, grown in terms of sheer numbers of members, and faced challenges ranging from financial to accountability of a small percentage of its adult membership for criminal behavior. The values upon which scouting began in this country have continued to hold meaning for its majority, and at its core, these are what *The Ideal Scout* embodies visually as part of the BSA's history and ethos. This is good as it warrants how the statue will preserve, so long as the Boy Scouts is preserved as an organization in America.

McKenzie was not alone in his quest to capture the essence of the scouting movement in statuary. Others accomplished this with varying degrees of success, ranging from the female sculptor Alice Robinson Carr and her two bronze statues and relief of scouts for a memorial to President Warren Harding in Seattle (1925), to the *Boy Scout Memorial* in Washington, D.C., by sculptor Donald de Lue (1964). Unlike

McKenzie's lifelike rendition of a scout, these others present figures that, while stoic and patriotic, appear stiff and wooden with their rigid posture, blank facial expressions, and linear visual design.

When considering the patronage possible from some veterans' groups, such as the Grand Army of the Republic (GAR), whose membership once numbered in the millions following the end of the Civil War, the proliferation of war memorials became a viable business for sculptors across the United States. Countless war memorials paid homage to the Union's generals, its leaders, soldiers of battlefields, and regiments from all across the United States. Sculptors were paid (and well) to model, sculpt, cast, and carve figures into bronze, granite, and marble as a way to permanently enshrine the victory, the history, and the legacy of those that served, fought, and died in the Civil War. Yet, with the diminishing membership of the GAR by the late 1940s, public calls for new GAR-sponsored memorials significantly diminished by that time.

While there was a steady downward trend in veteran-commissioned war memorials after the 1950s, the marked demand for war memorials before this time has contributed greatly to the figurative public sculpture found throughout the United States today. Noticeable peaks also exist for commissions in public statuary which focused on war themes or figures where these coincide with the years immediately following the end of major American conflicts, from the Civil War to the Gulf Wars in Iraq. In the case of memorials and statuary depicting Confederate figures, there was an actual increase in demand and resultant public sculpture commissions for these between 1880 and 1930. Much of this demand was driven by groups comprised of Confederate veterans and their family members who sought to memorialize the military service and heritage of its members, such as the United Daughters of the Confederacy (UDC), the Confederate Soldiers of America, and the United Confederate Veterans. The timing for these "memorialization" efforts could be directly correlated to the dying off of these veterans, and their internment into cemeteries.

During this same time period, other, non-veteran organizations sought to promote the ideology and values of "The Cause" through these new sculptures, with heritage and history serving as a cloak for preserving a darker legacy of the South that dated back to the American Civil War.

Financing also was a key to the proliferation of public sculpture, with the design and production of war memorial statuary proven to be a big business for both American and foreign sculptors. McKenzie himself sculpted several war memorials during his career, including *The Homecoming* (1920–1922) in Cambridge, England; *The Volunteer* bronze statue (1923) from the Rosamond War Memorial, Almonte, Canada; *The Call* bronze statue (1923–1927) from the Scottish-American War Memorial, Princess St. Gardens, Edinburgh, Scotland; and *The Victor* (1925) in Woodbury, New Jersey.

In some respects, war memorial statuary has also demonstrated its potential with American audiences through mass-produced copies, similar to the demand seen for *The Ideal Scout*. One example of this was the popular statue made by Allen George Newman, titled *The Hiker*, which depicted a soldier from the Spanish–American War of 1898. The installation of the first bronze casting into a veteran's cemetery in Providence, Rhode Island, took place in 1911; by 1940, a total of twenty-one copies of the statue had been installed into cemeteries and parks across the United States, with the last one in Ypsilanti, Michigan.

Yet unlike McKenzie's statue, which continued to be in demand for decades following his death in 1938, the downward trend in war memorials has a very definite tie to the continued existence (or lack thereof) of veteran groups and their endorsement, support, and call for new or existing war memorials nationwide. After World War II, new public sculptures that memorialized war figures, events, and locations were focused primarily on veteran cemeteries, military installations, and national memorials and parks. This trend has been even more pronounced for Confederate war memorials and monuments. While their proliferation was initially widespread in the late nineteenth and early twentieth century, their continued role and presence as public sculpture has undergone considerable scrutiny in a more enlightened light of the twenty-first century.

The *Ideal Boy Scout* has needed no such re-examination. The light and spirit of youth that McKenzie endeavored to capture in his *Scout* statue has continued to resonate with the scouting membership and general public alike. This has led to a continued demand for the statue and its placement in front of council buildings and other scouting sites nationwide. In the case of the statue in Portland, the occasion of a new statue was marked by the reopening of the service center for the Columbia Pacific Council on March 8, 1972.

Identified in its dedication plaque as *The Scout*, the statue was commissioned and donated by a former Eagle Scout, Zenon C. R. Hansen, who served as the council's president from 1949 to 1951. The dedication in the accompanying program noted how the statue "will not only serve to perpetually honor scouting's leaders, but to additionally recognize benefactors who extend the program to more boys by making possible additional staff personnel."[11] The placement of the statue in close proximity to the new council's building here mirrors the same placement at many other sites around the country, in front of Scout headquarters, Scout camps, Scout reservations, and other council service centers.

At the international level, *The Ideal Scout* has also been displayed as a public sculpture, personifying the scouting cause and its history, values, and identity. Locations include the National Headquarters of the Boy Scouts of Canada in Ottawa, Ontario (1963) and at the International Training Center for Scouters, in Gilwell Park, Chingford, London, UK.

One other location offers the iconic Scout statue. This is the copy at the University of Pennsylvania, installed in the R. Tait McKenzie Gallery. The sculptor died in 1938, one year following the completion of his new and most prolific sculpture. Its presence continues to embody his beliefs in the scouting movement and all that it has achieved both past and present.

The Ideal Scout by R. Tait McKenzie (1937). Bronze-cast statue copy installed in 1972 at Columbia Pacific Council, Portland, OR. Photograph 2017.

8

ALEXANDER VON SVOBODA (1929-2017)

Resourceful, methodical, and possessing an ability to combine multiple types of media into a coherent public sculpture: these qualities and more all described the sculptor Alexander von Svoboda, as well as the foundations of his two monumental public sculptures for Portland.

Svoboda's story begins far removed from his longtime studio in Canada. He was born in Lambach, Austria, on April 16, 1929. The artistic tradition ran in his family—his grandfather, August Roeseler, was an accomplished German cartoonist. Life was good, and the young Svoboda enjoyed life in a well-off family and studies in art school in Vienna until the age of fifteen.

In 1944, the teenage Svoboda was enlisted into service with the German *Wehrmacht*. He was captured on the Russian front and then sent to a labor camp in Siberia. He escaped and made a trek over 6,000 miles back to his ancestral homeland in Austria. It was after his return that Svoboda recalled an incident that was both humorous and life-altering:

> He was mocking four American officers and their fancy fishing gear when he plucked a trout from a stream with his bare hands in 1945. One of the officers was General George Patton … the boy became Patton's interpreter. Von Svoboda ended up designing U.S. Army chapels and other facilities across the continent, giving him chances to study art in Vienna, Paris and Rome.[1]

However, opportunities to further himself as an artist beckoned abroad. In 1950, Svoboda immigrated to Toronto, Canada, where he sought work as a commercial artist. He arrived a pauper, with only $10 to his name. Two years later, he was a successful commercial illustrator for the Simpson-Sears catalog. The design aspects of this work were the opening steps to a career in specialized interior design over the next three decades. Much of this work was done for churches: liturgical art, with statuary, stained glass windows, carpets, murals, and mosaics done with colored glass tile called "Smalti." These collective works showed religious scenes from the Old and New Testaments, along with Christian icons such as the Virgin Mary, Jesus Christ, Saints, Apostles, and other

figures from the Bible. His achievements in liturgical artworks earned him recognition in 1965 from Pope John XXIII at the Vatican in Rome.

By 1964, Svoboda had already achieved a lifetime of artwork, with the majority of these commissions done for either religious sites, or for the interiors of hotels, restaurants, private clubs and residences, and schools. The majority of these works were done in a muralist style that was colorful and expressionistic. It was during this year that he also began to expand upon his vision for sculpture in the round, into the forum of public art on a much more visible scale.

The Vancouver Court House square was undergoing a complete redesign in 1964, an effort led by Vancouver's Premier W. A. C. Bennett. The area—officially identified as Block 51, North Plaza—had been fronted by the Vancouver Court House since its opening on September 18, 1912. The building was a Neoclassical design, and from the very beginning clashed visually with Bennett's new Formalism and modernist vision of the square. Entering into this city planning effort, in a major way for the project, were Robert H. Savery and Svoboda, commissioned to create the design and the artistic elements, respectively, of a new centralized fountain for the square.

Savery's original layout called for Svoboda to create a center fountain sculpture in a reflecting pool that extended out from a basin inlaid with independent Smalti mosaic murals. Bennett's direction was specific, reflecting his desire to see the fountain serve as a monumental piece in both size and grandeur; the "XXL" fountain was to measure 72 feet by 26 feet and stand 16 feet high.[2]

Both city officials and the Premier envisioned the fountain as a centennial marker for the anniversary of the colonial union between British Columbia and Vancouver Island in 1866. The artwork was so dedicated as *B.C. Centennial Fountain*, at a total cost to the provincial government of $250,000. Per Bennett's direction to keep public awareness about the new fountain to a minimum, Svoboda's artwork was unveiled in darkness at 7 p.m. on December 15, 1966.

Several changes were made by Svoboda in the course of the modeling and design process for the fountain. Its final dimensions were somewhat smaller than what Bennett had proposed, but they were still impressive: 72 feet long by 36 feet wide, with a center basin that measured 10 feet in diameter. The entire fountain could circulate 300,000 gallons of water each hour and was equipped with three jet sprays of water that reached a height of 60 feet. Lighting within the fountain was also part of the effect, as thirty lights in each end pattern and twenty-four lights around the center, with twelve lighting display combinations achieved every three-minute cycle.

Of the sculpture's figurative reliefs, a non-attributed description from the dedication day has described these as "meant to represent mankind rising from the sea and depicts gods of Celtic mythology."[3] For Svoboda, the monolithic sculpture was a milestone in his career, marking his entry into commissions for public sculpture projects on a grand scale. His vision for the work combined both two-dimensional mosaic design—which symbolized the sea in its colorful, twisting patterns—with the two pillars of black marble in the center, with its sculpted reliefs of legendary Celtic figures perceived as a long-haired woman holding a chalice, suspended above the head of a long-haired, bearded grimacing visage below.

Both the choice of these figures by the sculptor and the rough-hewn appearance of the monoliths themselves were deliberate. In the case of the former, Svoboda sought to align

BC Centennial Fountain by Alexander von Svoboda (1966). Bronze-cast sculpture with colored glass tile (Smalti), installed at Block 51, Vancouver, BC, Canada. Photograph 1966. (*Alexander von Svoboda Papers. Image courtesy of Tanya Bull*)

the ancestry of the population of British Columbia with Celts and Gaels, an ancient people that included the Britons, Scots, Picts, Irish, Welsh, and Gauls. For the monoliths, the design was intended to invoke the rugged coast of British Columbia, the water of the fountain washing over them like sea-washed rocks from the shores of Vancouver. The importance of this symbolism employed for the design of the fountain was repeated by Svoboda in other public sculpture projects.

The timing for the completion of *B.C. Centennial Fountain* led to a new opportunity for the sculptor for his next major commission. The focus was another fountain, again accompanied by a central sculpture element, for a new building site in Portland, Oregon. However, unlike the backing for the Vancouver fountain, the patron for this sculpture was a private company with its own major construction project—a new Georgia-Pacific (GP) Company's headquarters building in the downtown business area of the city.

On November 24, 1967, Svoboda received a letter from D. A. Pugh, a partner in charge of the new headquarters building project and coordinator for the building's

sculpture sub-committee. Pugh stated right off that members of the committee had been impressed with *B.C. Centennial Fountain* and were interested in Svoboda potentially taking on a new commission for their Portland headquarters.

The letter served to both solicit examples of other sculptural work Svoboda might provide, and to also hear his thoughts about what sort of sculpture might best be created for it. At this stage, the GP planners had two possible spaces for the new artwork—either to the left of the main front entrance, or in the plaza court directly beyond the escalator lobby—and considered Svoboda's input on these as critical to any commission. Pugh summarized this with the added comment that of the two options under consideration, "it has been the desire of the building committee to have a fountain with sculpture at the main entrance."[4]

Svoboda's acceptance of the GP commission provided him with an opportunity to expand on his figurative design ideas for a new fountain. Pugh had shared photographs of the building's proposed design, and Svoboda used these in his plans for the new sculpture.

The result was a monumental presentation of five figures, all nude, entwined and floating together in a curving, graceful arc: three women, one young man, and a child. The sculptor offered his perspective on its representational meaning and its style with respect to the new building:

> It depicts the growth of today and tomorrow and the awakening to the future. It is symbolic of man's eternal search for brotherhood and spiritual enlightenment. I wanted to have complete contrast between this piece of sculpture and the Georgia-Pacific Building. The sculpture is designed to lead the beholder to look towards the middle of the building and then up.[5]

The sculptor's view of the figures as symbolic of humankind's values and aspirations ties directly back to his previous work in religious artworks. Svoboda created over 250 murals and church interiors in his lifetime, up until the Georgia-Pacific commission— the notion of creating something that was not sacred or secular was a foreign notion to him as an artist. He also viewed the creative process as a natural one: "I'm not the type who sits about waiting for an inspiration, for some mood to strike me ... the hand creates because I lead it."[6]

For most of 1968, Svoboda modeled his design for the new sculpture, called *The Quest*, in his Toronto studio out of clay, then as a plaster-cast model. Yet, the vision for *The Quest* was much grander in terms of overall scale, with the final size of the figures five times greater than the life-sized model.

For his material, there was only one choice for the sculptor: pure white marble. Yet a major challenge was finding a site where a single block of marble could be successfully quarried. However, pure white marble in layers of more than 4 to 5 feet was hard to come by, as the sculptor soon discovered. His investigations into quarries in Italy yielded no positive results.

In 1969, while waiting in Rome for a layover flight from visiting his father in South Africa, Svoboda noticed some carved white marble figures in an airport gift shop. Curious, he asked about where these had come from; he was told Athens, Greece. This chance encounter led him to travel on the very next flight to Athens to investigate further a possible source for his marble.

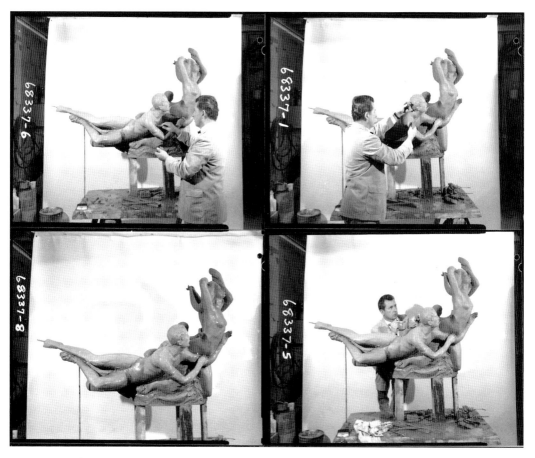

Series of four photographs showing Alexander von Svoboda modeling *The Quest* in his Toronto studio. Photograph 1968. (*Alexander von Svoboda Papers. Image courtesy of Tanya Bull*)

Svoboda described his efforts to secure a source of quality material for his new sculpture:

With a taxi I started to inspect the few quarries I could find, but there was no commercial production there. I had a very bad time to communicate with the people, not speaking Greek. Most of the quarries could not produce a large block of marble, as I wanted. The marble looked great but was very hard and most of the blocks had rotten pockets inside, so there was no guarantee that a larger block would be pure of veins or rotten pockets. With a very bad translator I started to negotiate with the owners of one of the mountain quarries. This quarry in the old days had produced the marble for the Acropolis he assured me, but since then was mostly unused. The owners and I stood on top of the mountain and negotiated the last price and finally agreed to do business.[7]

While locating a source for the white marble was a major accomplishment, the next phases proved to be equally challenging. Through the use of hand chisels, steel wedges, trenches 1 meter deep, and wood beams, the sculptor directed a team of Grecian workmen

At the Quarry in Greece. Site of the 190-ton marble block used for *The Quest.* Photograph 1968. (*Alexander von Svoboda Papers. Image courtesy of Tanya Bull*)

to separate a block of marble from the mountainside. The 200-ton block measured nearly 30 feet long and 20 feet high and wide. Svoboda's foreman, Enricco, believed at the time that it was the largest single white block ever quarried in modern times.[8] All of this work was accomplished without the aid of heavy machinery.

The sculptor had established a makeshift studio close to the harbor in Athens, where the carving of the figures could begin in earnest. Yet he still had to move the massive block down the mountainside. Old fashioned methods were the solution as he purchased ship ropes for the hauling, and paid farmers from around the countryside to bring in teams of oxen, 200 of them total. The block was pulled across sand laid in the path, over 60 miles to the studio destination.

Once arrived at the worksite, Svoboda had assembled another team of thirty stonemasons from around the globe to help with the carving of the sculpture. These workmen were Greek, Italian, German, and Arab—all different nationalities and speaking different languages; truly a multicultural effort. To make himself understood, Svoboda resorted to a form of sign language and gestures, always coordinating what areas each mason needed to focus on from the scale design.

More challenges awaited the sculptor. Not even halfway through the carving process, Svoboda learned from a new acquaintance in Greece—shipping magnate Aristotle Onassis—that changes to the government and property ownership might lead to the sculpture's confiscation. Onassis offered to ship the uncompleted sculpture out of the

country. Svoboda made plans accordingly, securing a new studio worksite in Carrara, Italy. The choice was somewhat ironic since Carrara was the original hoped-for location where the marble might be found.

Svoboda also made arrangements for his team of multi-national workmen to accompany him to Italy. With the help of Onassis, the incomplete sculpture was shipped safely out of Athens to Carrara, where the work continued to refine its details. When finished in spring 1970, the massive sculpture—titled *The Quest*—weighed 17 tons and measured 20 feet long by 10 feet wide and 15 feet high, ready to ship to the United States, with Portland as the final destination.

Svoboda was used to working on an impressive scale for his art. His mosaic mural *The Last Supper* for the Cathedral of St. Peter-in-Chains, in Peterborough, Ontario, required 633,600 pieces of hand-cut and hand-placed mosaic tile over six months to complete in 1968. The sculptor was also continually active—in 1967, the year he received the commission for *The Quest*, he completed work on new paintings, murals, sculpture, and interior designs for North Albion High School, Sacred Heart Church in King City, and fourteen other schools and churches in Canada.

On June 18, 1970, Count Alexander von Svoboda, accompanied by his wife, Helen, attended the dedication ceremony for the unveiling of *The Quest*. The occasion marked the near-completion of the Georgia-Pacific's thirty-level world headquarters building in downtown Portland, with the company's most recent addition to its corporate art collection numbering close to 400 works. The princess of the International Rose Festival unveiled the city's latest public sculpture addition for that year, with the moment marked by "a momentary stunned silence then crescendo of applause."[9]

Svoboda was able to soon capitalize on the success of *The Quest*, with his next, second major public sculpture commission that same year. Impressed with his accomplishment, Georgia-Pacific again called upon the artist to render a new piece for display as part of their permanent art collection. This new work would offer more direct ties in both its material and creative process to both the timber company and the West Coast as a region.

For this new design, the sculptor utilized the workers of GP to harvest a giant sequoia redwood tree, from which a cross-section measuring 32 feet in diameter was cut to form the foundation of the sculpture.

The sculptor's concept was again influenced by a desire for spiritual representation. By combining the essence of the natural environment as part of the design. Svoboda used 4.5 tons of bronze to construct a "seedling" form in the center of the hollowed-out tree ring, suspended by a network of outwardly radiating bronze rods that extended out from the surface of the tree in a sunburst effect.

The sculpture took two years to complete and was installed at the Georgia-Pacific Headquarters building in 1972. Titled *Perpetuity* by Svoboda, he called it "perpetual, the beginning and end of life, or to say another way, there is no end and no beginning."[10]

In 1982, Georgia-Pacific moved its corporate headquarters from Portland to Atlanta, Georgia. This left the fate of Svoboda's two prominent public sculptures in doubt. However, both were acquired by Standard Insurance Company, when they bought the building where the sculptures were physically located. *The Quest* has remained in place over the years, in its original placement in 1970, while *Perpetuity* was relocated when donated to the World Forestry Center and reinstalled at its Merlo Hall.

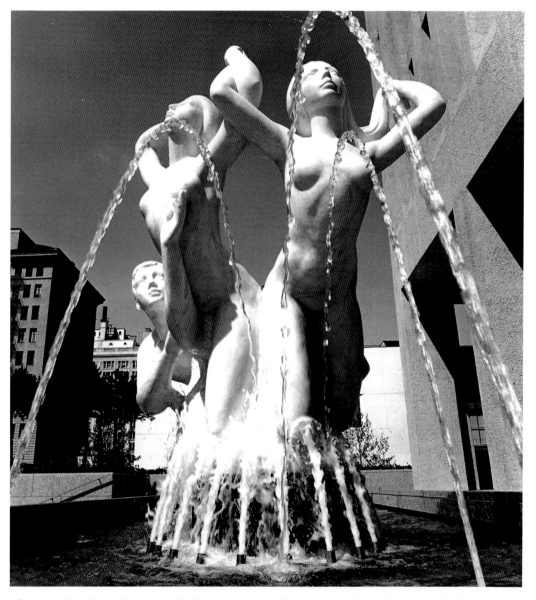

The Quest by Alexander von Svoboda (1970). Pentelic white marble sculpture, Portland, OR. Photograph June 18, 1970. (*Alexander von Svoboda Papers. Image courtesy of Tanya Bull*)

As for Svoboda's *B.C. Centennial Fountain* in Vancouver, it was removed by the city in 2014 as part of a redesign of the Block 51 plaza area, by that time the shared site of the Vancouver Art Gallery (which took over the courthouse building in 1983). The removal was partly motivated as a result of the fountain leaking water into the Gallery's basement storage. Other criticisms had been voiced over the years since its installation— that the fountain and its surrounding mosaic pools were too large in scale for the courtyard square, or that its modernist design as a public artwork clashed visually with the Neoclassical design of the adjacent courthouse building.

The sculptor was surprised when he learned of the plans for the fountain's removal. His reaction was a natural one when faced with the prospect of losing his first major public sculpture. Svoboda noted the connection to the province's first European settlers and its uniqueness as a public artwork as context, which argued for its retention:

> You spend the money to remind the people who came first to Vancouver—who made Vancouver. Now it's being discarded like that? I did something for Vancouver and for British Columbia which was never done before. Nothing major like this was ever done in North America.[11]

As unwelcome a development as this was to its creator, the fountain's permanent removal proceeded as planned with the artwork placed into permanent storage.

Following the installation of *Perpetuity*, Svoboda continued to work on new art commissions that continued his lifelong focus and passion for creating liturgical subjects. New interior design projects contributed to his artistic visions in two locations in Barbados, while new sculpture projects included an installation titled *Homeward Bound*, showing sculpted Canadian geese in flight for the Canadian Embassy in Riyadh, Saudi Arabia (1985), and two others in his home city: a large bronze statue of Pope John Paul II (1984), and a metal sculpture for the Fireman's Training Academy and its memorial courtyard (1970).

While his record of public sculpture included several major commissions both in North America and abroad, Svoboda's long and distinguished career as an artist focused primarily on painting and mosaic mural work. This was especially true following the commissions for the two Portland sculptures, where he rededicated his life to painting as a creative medium. In all, some 2,000 paintings were achieved over his seventy-two years as a practicing artist, with many of these done as large multimedia works in a modernist style, smaller paintings done as tempera works on paper and oil on canvas, and using the Smalti mosaic technique.

His sculpture *The Quest* has continued to remain one of the first and finest examples of a modernist public sculpture still on display in the city of Portland, and the largest existing sculpture in the United States to ever be created from a single block of Pentelic white marble.

9

RAYMOND KASKEY
(BORN 1943)

The ascendancy of municipal art commissions and related city committees to determine the criteria, selection, and scope of public sculpture projects took place in the second half of the twentieth century in the United States. Portland was no exception to this development as public spaces such as parks, street corners, public squares, and government building sites required a more transparent and democratic approach to how a particular sculptor's work could find a permanent place for all to see. The financing of new construction projects, managed as a city- or county-approved process, factored heavily into new roles, regulations, and processes by which artists (including sculptors) had to apply for consideration to secure funding and support for new public art projects.

There were still cases in this new era where a sculptor could gain recognition and commissioning for new sculpture placed within city boundaries through the effort and patronage provided by private companies and their property interests. Svoboda's successful installations of *The Quest* and *Perpetuity* were just two of these, privately funded by Georgia-Pacific in the 1970s. Yet the majority of new commissions after this decade fell into the purview of a more centralized group of arts advocates, charged with city authority to collectively determine the direction of new public sculpture that could benefit Portland. The construction of new buildings was not exempt from this oversight, if the artwork or sculpture was one that took up residence as part of a municipal building or space and was supported by some sort of public funding managed by a city or county arts program. Such was the case for the *Portlandia* statue.

Enter Portland's Metropolitan Art Commission and its open call to sculptors nationwide for a new statue personifying Portland in 1981. Many of the details of this commission were already predetermined, even the stipulated title of the artwork: *Portlandia*.[1] The announcement was timed in anticipation of the 1982 completion of its display venue, the Portland Building, which served as a new office building for the city's Parks Department, water bureau, and other agencies. Architect Michael Graves, from Princeton, New Jersey, had been selected to design the new building at its downtown location. Graves' design was in a postmodern style, fifteen stories tall, with multicolored

materials in the building's façade. The roof of the first story formed a natural display area, with the remaining stories set back from the front of Southwest 5th Avenue.

Over 200 artists responded to the design competition for a new statue to be displayed atop the Portland Building. This is where the review and deliberations of the Metropolitan Art Commission found common ground with a sculptor who looked to the past to inform and shape his choice of figure, style, and material as part of the creative sculpture process.

Ray Kaskey was a sculptor from Washington, D.C., who had entered the competition with the idea that the statue should reflect an allegorical representation of Portland. He first learned about the competition through a newsletter from the National Sculpture Society, of which he was a member. Kaskey was selected as one of five semi-finalists for the commission; he was given two–three months to create a three-dimensional model for the next round of review in the fall of 1982.

His design was figurative and grounded in realism regarding the anatomy of the female character he envisioned on a grand scale. In this respect, Kaskey did not differ greatly from the designs of the five other semi-finalist artists who sought the commission. All of the designs referenced materials Graves had provided in advance, which clearly desired a postmodern sculpture or statue, figurative in nature and based upon the established identity of the city *vis-à-vis* its official city seal.

Kaskey's design, titled *Portlandia*, drew upon a number of historical references to other artworks and Portland history, combining these with his own contemporary models for the features of the female figure. Several details seen in the statue were adopted from the central figure, "Queen of Commerce," as seen in the city of Portland's official seal adopted in 1878. The seal's figure is a woman standing near a body of water; in her right hand, she holds a trident, while her left gestures towards a sheaf of grain and stand of fir trees, representing Portland's agricultural and forestry businesses respectively. The figure wears a sleeveless robe or dress, has shoulder-length hair, and towers over the landscape. These were all visual features and details that Kaskey incorporated into his new statue, albeit with minor differences: the long hair of his female figure was shown blown upwards, while the right hand reached down and the left hand held the trident (reversed from the seal's figure).

Kaskey drew from his own past experiences as an artist as well to further the design. He recalled his study done of a Rodin sculpture years before—*Crouching Woman*—where he had used a male studio model to create his own version of this figurative sculpture.[2] From Rodin's earlier work, he took details of the figure's right arm and leg and added these to his new model for the *Portlandia* study in clay. The sculptor recalled how another work—a painting, *The Ancient of Days* by William Blake —served as the primary inspiration for the kneeling posture of Kaskey's female figure.[3]

As inspired this model was by past artists, realism was equally important to the sculptor in creating his new design. For the details found in the female figure's face, he looked to his wife, Sherry, as the portrait's subject and source. Other proportional details—the graceful arms, the right hand pointing downward, and the left hand raising aloft the trident—were created with the assistance of an unidentified "out of work actress in DC" whom the sculptor hired to pose in his studio.[4]

The finished maquette for Portlandia was one-tenth to scale, compared to the final anticipated statue which was mammoth in size: from the base to the tip of the hair

measured 25 feet, with the trident at the highest point of 36 feet. His *Portlandia* was selected by the Metropolitan Art Commission as the winning design, with a contract for the statue signed on December 15, 1982.

There are several key considerations worth noting about Kaskey's approach to the design, and the deliberations and resulting decision by the Metropolitan Art Commission to accept it as the winning one. Kaskey's early training as an architect took place during the rise of modernist art in general and abstraction as an art form and style in particular. In 1965, a fellowship allowed him to study for a year abroad in Rome, where he developed an appreciation for the old masters and their influence on design. He described how this ran counter to contemporary teachings, and its later-found value to him as a practicing sculptor:

> Well, you're confronted with the grand tradition and you are not prepared for it by architecture school, where the main idea was to throw everything out and start all over again. To copy anything made before 1914 would have been laughed out of the drafting room. I was guilty of that myself, when I become a teacher.[5]

Kaskey earned his master of arts degree from Yale in 1969, and he spent the next seven years teaching in the architecture department of the University of Maryland. In 1976, he began his transition to working as a full-time sculptor. He self-taught himself to model the human figure while pulling away from abstraction to embrace figurative realism in his work. Much of the inspiration for this move he attributed to the work of sculptors before him:

> The search for a more particular image out of the spatial exploration led me to a dead end. What I didn't know at the time was, the image was one of classical art. The more the artist loses himself in the great tradition of Western sculpture, to the point of almost anonymity, the more I like it … The tradition is 2,000 years old, it is part of our minds … why not use it?[6]

Kaskey's concept and proposal for *Portlandia* was a culmination of this new mindset for the sculptor. While his proposal to the Metropolitan Art Commission was heavy on narrative description for his idea, he had few visual sculpture examples to offer along with it, aside from some designs for decorative medallions and capitals for some townhouses by Robert Bell.

Yet the strength of the design itself argued in its favor as an informed classical design that incorporated the history of the city via its official seal along with elements from the artwork of both Blake and Rodin.

The final design won approval owing to other considerations taken into account by Kaskey. His proposal called for a kneeling figure of the statue, which the sculptor had determined to be advantageous both as a cost-saving measure (the city's budget for the sculpture was just $224,000) and in its acknowledgment of Graves, the architect, who had proposed a flying allegorical figure above the entranceway as an initial concept. Kaskey ended up conveying this windblown effect in both the swirling hair of the female and in the lifted portion of the robes on the figure's left side. He characterized this as a good detail seen in the figure and its role as an icon for the citizenry onlookers from

Study for *Portlandia* (1982) by Raymond Kaskey. (*Raymond Kaskey Collection. Image courtesy of the artist*)

below: "It suggested sea breezes and seemed a good symbol for the city of Portland."[7] The sculptor also removed from his original design a wreath that was held in the statue figure's down-stretched right hand. A new design that omitted the wreath entirely was endorsed as an improved version by the jurors on the commission review.[8]

Abstraction, by its very nature, symbolizes nothing. It is defined in modern art as an expression of absence, whether this is a painting, mixed media installation, or a sculpture in the twentieth century. What the *Portlandia* award to Kaskey represented was a confluence of like-minded creatives seeking a public sculpture that would define Portland and its identity. In this respect, it was both a new vision and a continuation of the sculptural traditions of the late nineteenth and early twentieth century in America.

While the design for *Portlandia* was a true continuation of American and European Neoclassical figurative sculpture in terms of artistic style, modeling, and representation, it also adhered to a practice of grand design with its surroundings, dramatization in epic proportions, and blended elegance with material volume of a sculpture media. Kaskey was afforded the space for this from the start, as part of the commission's criteria, and he succeeded in the proportional aspect of his figure. In fact, he made it kneeling so that it could fill in the ledge space above the entranceway of the Portland Building. His choice of a medium was equally well-conceived and inspired by a friend's suggestion that he use the same pounded-copper method employed by the French sculptor Auguste Bartholdi to create the Statue of Liberty.

While the idea for creating the new statue using the copper *repoussé* technique had great appeal, it presented a number of challenges for the sculptor. First, Kaskey needed a larger studio on the East Coast to accommodate the work while in progress. His search

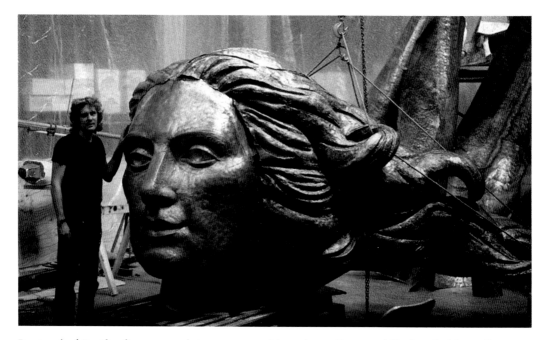

Postcard of *Portlandia* as a work in progress with sculptor Raymond Kaskey in his studio. (*City of Portland Archives & Records Center*)

for a suitable space in 1983 called for a room with a ceiling at least 30 feet high, along with a sufficient clear area around to allow for the hammering of the thin copper plates and assembly of these into the statue.

Kaskey and his assistants needed special tools that included blacksmith hammers and whittled-down croquet mallets, in order to hammer and shape the cooper into the figure's form. One estimate placed each piece as having been hammered fifty times. The assembly process also required research into the type of fasteners needed, so that corrosion would not set in over time. This had been a factor in the deterioration of the Statue of Liberty's steel fasteners, when their contact with the copper skin of that statue had resulted in electrolysis over time, causing it to rust and deteriorate.

To prevent a similar effect in his statue, Kaskey devised a steel framework for the statue's interior structure, employing stainless steel bolts and nylon washers to ensure that the steel and copper did not come into contact with each other.

Another characteristic found in the Statue of Liberty was its weathering effect with the elements over time, which turned the copper exterior skin color of the statue to a greenish-hued patina. This was a desirable effect anticipated for *Portlandia*, one which the sculptor attempted to replicate prior to the statue's installation in Portland. He used the chemical cupric nitrate applied to the copper surface to "speed up" the natural oxidization process. However, Kaskey's efforts to create a natural green patina uniformly were unsuccessful, and the statue retained its copper-penny color. *Portlandia* has not lost its copper hue over time, attributed to the periodic cleaning and care administered to the statue as part of the city's public art collection.

While the sculptor had purposely modeled the face of the sculpture after his wife, this was balanced with a desire to present the figure as an allegory for the city. To this end, he minimized the emotion found in the visage during the modeling process in his studio: "I tried to get away from all expressions in the face. I wanted a repose, perhaps sorrowful, perhaps passionate, perhaps strong."[9] This approach was decidedly one that left the viewer to make their own observations about what the figure represented to them.

Costs for the project were an ongoing concern for the sculptor. In the final analysis, Kaskey was able to complete the statue for $198,000; yet in spite of coming under his original contractual budget, there remained the task (and cost) of seeing the new statue transported and installed.

The expense for the transport from the sculptor's studio in Cottage City, Maryland, to Portland, Oregon, was high—$30,000. While Kaskey had used his financing from the commission to pay for the statue's materials and labor, the transport cost was something that threatened the project's completion. As a result, a fundraising effort was initiated by volunteers in Portland. By January 1985, the effort had raised about one-third of the funds needed, with the collection coordinated by Norma Gleason, an administrator for public art projects at the Metropolitan Art Commission. Among those donating to the cause were pledges of shipping supplies from Georgia-Pacific along with $500 from students at Tualatin Valley Elementary School in Portland.

By September 1985, Kaskey had completed his modeling of the 26-foot-high figure in nine pieces, successfully transporting it cross country to a warehouse in North Portland on the Willamette River, arranged through the Transportation Club of Portland and Emmert International. At the warehouse site, Kaskey and his team assembled the statue, then supervised its loading aboard a barge via crane on October 4, 1985.

Above: Portlandia on its barge, in transit to the Portland Building. Photograph date October 4, 1985. (*City of Portland Archives & Records Center*)

Left: Portlandia by Raymond Kaskey (1985). Copper *repouseé* statue, Portland Building, Portland, OR. Photograph date October 9, 1985. (*City of Portland Archives & Records Center*)

The statue was offloaded from the barge two days later on October 6 and trucked through the downtown area aboard a flatbed trailer as a crowd numbered in the thousands looked on. It traveled six blocks to the new Portland Building; it was then offloaded and installed using another crane that very same day. Weighing 6.5 tons, *Portlandia* was the second-largest copper *repoussé* statue after the Statue of Liberty. Among those watching the scene was the novelist Tom Wolfe, who later compared Kaskey's *Portlandia* to Michelangelo's *David* sculpture being dragged through the streets of Florence to its location in front of the Palazzo Vecchio.[10]

The dedication and public unveiling took place on October 8, 1985. Among those in attendance were the sculptor and his wife, members of the Metropolitan Art Commission, city commissioners, and other past and present elected officials. The occasion was marked with a celebration fitting of the sculptor's achievement.

While the contract with the Metropolitan Art Commission specified that the new statue would become the property of the city of Portland, the sculptor had included a clause that allowed him to retain copyright to the original design of *Portlandia*. In the year following the public installation of the monumental statue, Kaskey produced a limited-edition series of 500 bronze statuettes of the design that were 8 inches high for commercial resale. The right to make reproductions of the design has remained with the sculptor ever since.

In 1998, there was a brief movement called for by Portland's mayor, Vera Katz, to relocate *Portlandia* from its placement on the Portland Building to an unidentified site on the Willamette River. The goal was to make the statue more visible to residents in both the east and west parts of the city. Relocations of public sculpture in Portland have been rare, and the prospect of Kaskey's sculpture being moved was no exception. *Portlandia* remained in place.

Upon reflection thirty-five years later, Kaskey has described the experience of creating his public sculpture for Portland and seeing it realized as one where "he died and went to Heaven."[11] He credits his accomplishment as one that could not have been done without the help of others, notably Charles Hall, a Portland resident who managed much of the publicity about the new statue and later became Kaskey's agent.

True to his prediction at the time of its dedication in 1985, today *Portlandia* views down upon its city street with a golden hue. It continues to remain a testimony to the work of previous American and European sculptors, as well as their legacy of public sculpture from the past century.

10

JAMES LEE HANSEN (BORN 1925)

In the second half of the twentieth century, one of the major shifts in the definition of what constituted a public sculpture was a correlating loss of anonymity on the part of the sculptor, in the creation of a new statue, plaque, memorial, monument, or relief. A sculpture installed into a town square, in front of a municipal building, or at the intersection of major avenues that featured a prominent figure in portrait detail, clearly identified as such with a dedication plaque if the visage escaped one's memory, might omit the name of the sculptor entirely with equal deliberateness.

A shift in how the public perceived sculpture as an art form accounts partially for this transition in artist recognition. As modern art as a global movement took hold with new styles and forms during the first half of the twentieth century (e.g. Art Nouveau, Art Deco, and Abstract Expressionism), the demand for styles and presentations of sculpture that reflected Beaux-Arts, Realism, Neoclassical, and figurative works began to slip from their dominance as the creation of choice for public sculpture. New demands for different works clamored for attention, with fashion, expressionism, and abstraction shaping the consciousness of the sculptor in America and the new work they produced for display. These new sculptures called forth a reciprocal demand for "interpretation" by the public viewer—no longer only modeled to convey a personage or memorialize an event, these sculptures became standard-bearers of creativity and the end product of sculpture as a medium for making art for art's sake.

With this shift came a newfound importance for recognizing the sculptor. Name recognition was synonymous with the style, visual brand, and flavor by which the sculptor (and artists of the twentieth century in general) could achieve individualized recognition through a body of work. The body of sculpture itself took on the identity of a sculptor: here we have a Calder, over here a Picasso, alongside a Brâncuşi and a Noguchi. The advent of modern art and its follow-up cousin, the Postmodernism movement, sought to define the creative world of sculpture through names, groupings of names, and shared visual characteristics.

In many respects, the public sculpture that came under this new identity of art differed greatly compared to earlier public sculpture in America and its focus on

realism, anatomical detail, aesthetic beauty, and dramatic pose of the figurative work. This disdain could partially be traced to the anonymous quality of many of these earlier sculptors, whose achievements in bronze, marble, and stone did not require them to create a wholly new interpretive look for their subjects. The new modernist sculptors took the world by storm following the end of World War II, and their ascendancy was all but assured in the process.

Under the loose heading of "modern art," these new public sculptures either eschewed the human figure entirely or relegated it to take a back seat to the sculptor's use of shapes and combinations of shapes, angles, curves, and space to define the viewer's perception. The statue of the soldier, the statesmen, and the explorer, along with all the deities, allegories, and personifications that had dominated American sculpture traditions, gave way to these sculptors of the new. Numbered among these new sculptors was James Lee Hansen.

Born in 1925 in Tacoma, WA, Hansen grew up during the Great Depression era after his family moved south to Vancouver at age eleven. He enlisted in the U.S. Navy at the outbreak of World War II, serving in the South Pacific theater aboard a destroyer, USS *Preston*. His return to the States in March 1946 marked the beginning of Hansen's formal training as an artist. Enrollment at the Portland Art Museum School under the G.I. Bill afforded Hansen the opportunity to gain studio instruction he would later utilize throughout his career as a sculptor.

Together with his first wife, Annie, the sculptor purchased property on the northeast side of downtown Vancouver. The process of constructing a new studio demonstrated Hansen's commitment to art as a profession:

> The Burnt Bridge Studio property was bought by Jim and Annie from Jim's father [his property adjoined this piece]. There was a small house existing on the property, which Jim and Annie used for a place to sleep and eat. Jim went to work on upgrading and remodel and building the studio and foundry while in Art School and Annie worked on the telephone swing shift. They lived in the two-room house while adding on to the house and creating the studio and foundry ... using all kinds of materials that were available and free: creative building in those days.[1]

By 1950, the studio was completed, with the foundry up and running by 1951. For the next twenty-six years, Burnt Bridge Studio would serve Hansen well as the location for the casting of his sculptures into bronze using the lost-wax method. This was a lifelong practice of the sculptor. By using a small maquette in wax that was not bigger than 6–10 inches, Hansen would create a design that allowed new details to be easily added over time.

The start of Hansen's first studio also marked the beginning of a new series of work that both defined his distinctive sculptural style and eventually contributed a piece to Portland's public sculpture displays. This was the *Equestrian* series of bronzes, with *Rider Study* (one of six) the first of these created in 1950.

These *Equestrian* sculptures that Hansen modeled took their substance from the title of the series, as each one portrayed a horse and rider, but they were rendered in such a way as to suggest the basic form of these together. Elements taken from the Cubist style, with its combination of curved and angular shapes, partly accounts for the designs

seen, but Hansen has also used sculpture as a medium to create these figures almost as symbols, instead of an animal or human depiction. To call them "abstract" would be an oversimplification. The symbolism inherent to figures and characters gives the series continuity, while making each one unique as well, as subtle differences have been added over time as the series has progressed from the sculptor's studio to the foundry.

By the sculptor's own account, this process of modeling the design may take years, with new versions of the sculpture coming forth from the one before it. This was the case for both of Hansen's sculptures found today in Portland—his *Winter Rider No. 2* from the *Equestrian* series and *Talos No. 2* from the *Guardian* series. In 2014, this outlook was one that still combined pragmatism and forces outside of the studio, with this timeless quality that has impacted meaning and creative direction for the sculptor throughout his career:

> The "progression" of my work is not well suited for the linear chronological assessments. It has never materialized as a series in a single vintage period or in a linear chronological sense. The body of my work might be best envisioned developing from a central point with an expanding sphere with separate spokes representing themes radiating from that axis point.
>
> My works gestate for many years in formative processes. Completion of a particular work, without the pressure of a specific commission, is seemingly arbitrary, involving factors of personal motivation, studio expediencies and financial imperatives that determine which works will be completed. Works involving various studies to full-scale piece may be completed in a time span ranging from a few months to many years.[2]

This timeless nature of Hansen's sculpture, as well as its ability to leap across the years through the same series, but through new iterations of the same motifs and the same cultural icons, is another part of the sculptor's signature as an artist. It makes the process of defining "when" the Portland pieces were created an exercise in existential gymnastics, albeit a moot one for the effect remains the same—starting and ending points for each sculpture are unimportant concerns, with the castings in bronze serving as waypoints in the sculptor's view of humanity and its civilization.

While the sculpture *Winter Rider No. 2* dated to 2003, its history, identity, style, and design may all be traced back to half a century earlier. The Portland sculpture in bronze was the second *Winter Rider* from the *Equestrian* series begun in 1960 that included three others: *Rider*, *Autumn Rider*, and *Mythic Rider*. Yet all of these works originated from an earlier concept of the *Equestrian* Hansen first defined in a small-scale bronze titled *Rider Study*, completed ten years before when he graduated from the Portland Art Museum School in 1950. The design for *Winter Rider No. 2* was completed much later in 2003, then sold three years later to a private collector, Douglas Goodman, for display at City Center Parking in Portland. Goodman loaned the piece to the city for public display, with the sculpture installed at the Portland Transit Mall in 2010.

The *Equestrian* series was specifically defined by Hansen as both a visual representation of "mankind's pursuits of romance and freedom by taming and harness the creatures of the wild" and "the interdependent bond of the spirit of the rider and the ridden."[3] Both of these interpretations apply equally as well to the timeless nature of mankind's existence, dating back to the dawn of civilization when humanity sought exploration, adventure, and independence with the help of domesticated steeds.

Rider Study, the first sculpture in the *Equestrian* series by sculptor James Lee Hansen (1950). Bronze-cast sculpture (edition 1/6). (*James Lee Hansen Collection. Image courtesy of the artist*)

Winter Rider No. 2 by James Lee Hansen (2003). Bronze-cast sculpture, installed at Portland Transit Mall, Portland, OR, 2010. (*James Lee Hansen Collection. Image courtesy of the artist and J. Scott Collard*)

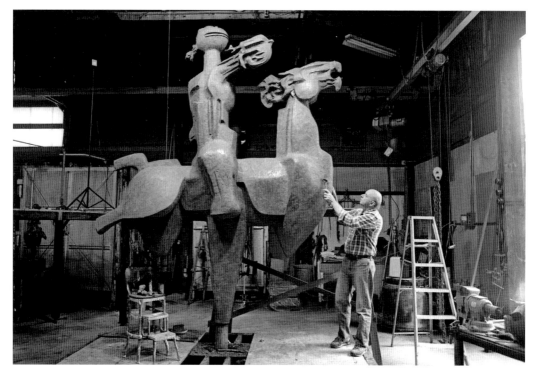

James Lee Hansen working on a sculpture from his *Equestrian* series. Daybreak Studio, Battle Ground, WA. (*James Lee Hansen Collection. Image courtesy of the artist and J. Scott Collard*)

Even more transcendent is the case made for Hansen's second public sculpture in Portland, *Talos No. 2*. The *Talos* series was part of a broader series called *Guardians*, which Hansen first embodied in his bronze *The Huntress* in 1952. Hansen applied the term "Guardian" in a direct way, with respect to mankind's cultural development through buildings, infrastructure, and other tangible achievements. The *Talos* were an evolution of this series and its design process. The new series was given its name by Annie, after the Greek mythological figure Talos, an enormous bronze man given by Zeus to King Minos to guard the island of Crete. Hansen conveyed the importance of the series in a letter to Louis Aaron, art editor for *The Oregon Journal* a year following the cast of the first edition:

> *Talos* is my major bronze to date. It cost one thousand dollars to cast and a year to complete. The form of *Talos* has known three mediums. First, the original clay, then as a transitional hollow wax sculpture, then finally the bronze. The full-scale wax model was to facilitate the bronze casting process ... perhaps the largest lost-wax process bronze ever cast in a private casting facility on the West Coast.[4]

This first sculpture of the series was simply titled *Talos* and was first created in clay at the University of California, Berkeley, while Hansen was teaching the summer session of

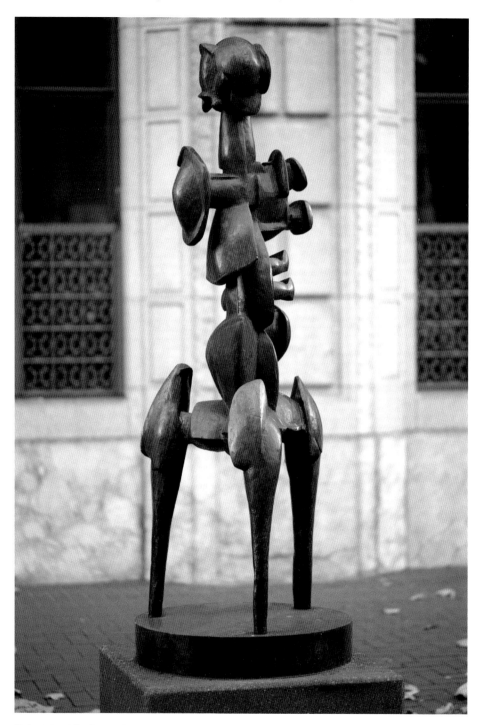

Talos No. 2 by James Lee Hansen (1959–1968). Bronze-cast sculpture, installed at Portland Transit Mall, Portland, OR, 1978. (*James Lee Hansen Collection. Image courtesy of the artist and J. Scott Collard*)

sculpture in 1958. He brought the clay sculpture back to the Burnt Bridge Studio after the summer session ended. The following year, it was cast into bronze and featured in the Third Santa Barbara Pacific Coast Biennial on October 9, 1959. *Talos* finally became a public sculpture when it was installed at the Fresno Mall, California, in 1965.

The second bronze in the series—*Talos No. 2*—began in 1959 and continued as a focus of the sculptor until 1968—nearly a decade to mark its completion. The third in the series was started in 1976 and finished in 1984; two years after the final casting work, *Talos No. 3* was purchased by the Seattle Art Museum for its permanent collection.

Hansen's ability to create a series of interconnected works through his designs over great spans of time was not just a characteristic of his studio process. This transcendence of time also extended to the display of his bronzes as public sculptures. Nowhere is this more evident than in the case of Portland and the two bronzes installed at the Portland Transit Mall.

While *Winter Rider No. 2* was installed in 2010, *Talos No. 2* predated the former artwork's installation by over three decades.

In 1978, the Portland Transit Mall was a recently completed corridor for mass transit through the heart of the city. New monitors offered commuters schedules of buses throughout the day at stations along the Mall. Hansen was afforded an opportunity to present the city with the commission of a new *Guardian*, which was significant as a means to connect the artist's vision of the sculpture with the identity of its new location.

The sculptor further defined this relationship between his bronze *Guardian* figures and their placement:

> They are the symbolic guardians of cultural systems, both political and religious. They are the primary images inherent in the constructs of civilization. Through all human history their various forms are the substantive imperatives: a sublimation of spiritual forces, the quintessential cultural artifact of human passage.[5]

In both the *Winter Rider* and *Talos* sculptures, the sculptor has a distinctive style that marks the appearance of these independent series as identifiable by the same creative source, yet differentiated enough in the designs that have changed with each bronze casting to make the sculptures unique. The impressions are the same when comparisons between works in the same series are made: the horse and rider—appearing at first glance as if carved from a carousel—are defined with the same basic angular proportions and curves in *Winter Rider No. 2*, as with the bronze produced before and after it. The pairing of this *Equestrian* sculpture with a new municipal transportation project was a fitting interpretation, where the identity of the sculpture matched the purpose of its surroundings. The Portland Transit Mall's *Talos No. 2* stands on three legs, looking out upon passers-by and street traffic with the same somber ambivalence its predecessor once watched with over the Fresno Mall.

The timing of Hansen's completion of *Talos No. 2* was fortuitous, indeed. That same year witnessed the closure of Burnt Bridge Studio to eminent domain by the state of Washington for a new construction project for State Route 500. Undeterred, Hansen located a new studio in June 1977 in Battle Ground, Washington, called Daybreak Studio.

Hansen has continued to maintain his independent spirit throughout his career as a sculptor. From his earliest days learning the medium, he turned down an apprenticeship

in 1951 to work with the sculptor Jacques Lipschitz, citing a belief that "nothing can grow under the shade of a big tree."[6] Other collaborations with northwest artists beckoned in 1959 with the Oregon Centennial Exposition and International Trade Fair, which Hansen helped to organize a workspace for the group and outfitted them with tools. The experience was fruitful. He produced five large murals for the Sheraton Hotel, and another 510-foot mural for the Centennial Exposition Building; however, Hansen chose to return to his own studio work rather than take on additional roles as an arts project manager.

As public sculptures, the paths that both *Talos No. 2* and *Winter Rider No. 2* have taken to become part of the city's landscape also differed from each other. While the *Talos* bronze was finished in 1968, it was included in three major art exhibitions before it was sold to the Transit Mall for placement in 1978. The *Rider* sculpture was in fact on display in Portland starting in 2006, before it was loaned by the collector to the city of Portland for display along the Transit Mall at SW Sixth Avenue and Stark Street four years later. In July 2015, *Talos No. 2* was knocked off its pedestal and subsequently removed for repairs. The sculpture was successfully reinstalled in its former location on October 30, 2015.

At the age of ninety-five, James Lee Hansen has created over 700 sculptures and independent projects during his long career. His bronzes are found in art institutions and collections throughout Oregon and beyond. The Portland statues inspire creativity still, in both their sculptor and those who see them now or in the future.

ENDNOTES

Chapter 1

1 Snyder, E., *Portland's Potpourri: Art, Fountains & Old Friends* (Portland OR: Binford and Mort, Publishing, 1991), p. 9.

2 "Skidmore Left a Fountain … and a Controversy," *The Sunday Oregonian* (Portland OR: November 9, 1941), p. 85. Stephen Skidmore died in San Rafael, California, in 1883, but he left $5,000 for the erection of a new fountain in Portland, OR. The commission was accepted by sculptor Olin Warner through his association with C. E. S. Wood, another Portlander who advocated for the city's first sculpture fountain.

3 "Gives a Fountain," *The Oregonian* (Portland OR: June 7, 1899), p. 8.

4 Thompson, D., letter to City of Portland (June 6, 1899) in "Gives a Fountain," *The Oregonian* (Portland OR: June 7, 1899), p. 8.

5 "Hero and his Horse will see unveiling," *Seattle Daily Times* (Seattle WA: April 25, 1913), p. 23.

6 "City News in Brief-Fountain Elk in Position," *The Morning Oregonian* (Portland OR: August 27, 1900), p. 7.

7 Thompson, D., letter to the Mayor and City Council of Portland re: *Elk* fountain (November 29, 1900), in E. Snyder, *Portland's Potpourri: Art, Fountains & Old Friends* (Portland OR: Binford & Mort, Publishing, 1991), p. 12.

8 "Important Americana—lot 1575 / Catalogue Note—American Elk," Sotheby's e-catalogue (2016) (sothebys.com/en/auctions/ecatalogue/2016/important-americana-n09456/lot.1575.html).

9 "Elks' Rest (sculpture)," record no. IAS MI000059, Smithsonian American Art Museum Arts Inventories Catalog (siris-artinventories.si.edu/ipac20/ipac.jsp?session=1C002A77324R0.314&profile=ariall&source=~!siartinventories&view=subscriptionsummary&uri=full=3100001~!319059~!19&ri=1&aspect=Keyword&menu=search&ipp=20&spp=20&staffonly=&term=roland+perry&index=.GW&uindex=&aspect=Keyword&menu=search&ri=1).

10 Libby, B., "The Elk statue is just fine," Portland Architecture—a blog about design in the rose city (August 24, 2020) (chatterbox.typepad.com/portlandarchitecture/2020/08/the-elk-statue-is-just-fine.html).

Chapter 2

1 Evans, S. A., "Club Work of Oregon Women," *The Oregon Daily Journal* (Portland OR: December 25, 1904), p. 16.
2 Jager, R. K., *Malinche, Pocahontas, and Sacagawea: Indian Women as Cultural Intermediaries and National Symbols* (Norman OK: University of Oklahoma Press, 2015), pp. 253–254.
3 "The Sacajawea Monument," *Daily East Oregonian* (Pendleton OR: October 25, 1904), p. 4.
4 *Ibid.*
5 "A good historical novel," *Oregon Daily Journal* (Portland OR: June 9, 1916), p. 10.
6 Evans, *op. cit.*, p. 16.
7 Snyder, E., *Portland's Potpourri: Art, Fountains & Old Friends* (Portland OR: Binford and Mort, Publishing, 1991), p. 14.

Chapter 3

1 Lewis, D. G., "Alexander Phimister Proctor in Oregon," NDN History Research (September 2, 2017) (ndnhistoryresearch.com/2017/09/02/alexander-phimister-proctor-in-oregon/).
2 Hassrick, P., "On the War Path," Center of the West.org (June 10, 2017) (centerofthewest. org/2017/06/10/on-the-war-path/).
3 Boehme, S. E., "Alexander Phimister Proctor and Gertrude Vanderbilt Whitney: Sculptor in Buckskin and American Princess," Center of the West.org (centerofthewest.org/2016/04/17/ points-west-proctor-and-whitney/). In 2004, the Proctor Collection was acquired by the Buffalo Bill Center of the West, which included the original plaster-cast model of *Theodore Roosevelt, Rough Rider*, in several pieces. The plaster casting was stored for years at the North Dakota Historical Society. In 2009, the complete model was reassembled when the Center's Whitney Western Art Museum was reopened to the public.
4 Gray, C., "Streetscapes—Readers' Questions: A Charmer that was ahead of its time," *The New York Times* (July 30, 2009) (nytimes.com/2009/08/02/realestate/02scapes.html).
5 "Dr. W.H. Coe Returns," *Morning Oregonian* (Portland OR: September 23, 1920), p. 4.
6 News reports place the unveiling of the statue on November 11, 1922. City property records from 1967 reflect that the statue was formally accepted by the city from Dr. Coe on October 25, 1922, with ordinance no. 41949.
7 "Statue is Picturesque," *Morning Oregonian* (Portland OR: November 4, 1922), p. 8.
8 *Ibid.*

Chapter 4

1 "Joan of Arc (1890)," Association for Public Art, [Philadelphia PA] (associationforpublicart. org/artwork/joan-of-arc/#).
2 Johnson, J. S., interview with F. Poyner IV (February 25, 2020).
3 "Joan of Arc may now be Canonized," *Oregon Daily Journal* (Portland OR: April 28, 1918), p. 4.
4 Snyder, E., *Portland's Potpourri: Art, Fountains & Old Friends* (Portland OR: Binford and Mort, Publishing, 1991), p. 100.

Chapter 5

1 "Ceremony Unveils Statue of Lincoln," *The Morning Oregonian* (Portland OR: October 6, 1928), p. 10.
2 Durman, D. C., *He Belongs to the Ages: The Statues of Abraham Lincoln* (Ann Arbor MI: Edwards Bros., 1951), pp. ix–xii.

3 *Ibid.*, p. vii.

4 Appelbaum, Y., "Take the Statues Down," *The Atlantic* (August 13, 2017) (theatlantic.com/politics/archive/2017/08/take-the-statues-down/536727/).

5 Durman, *op. cit.*, p. 116.

6 "Abraham Lincoln Statue," Record File PC-29, City of Portland Archives & Records Center (Portland OR: Bureau of Property and Control, March 19, 1968), p. 2.

7 Waters, G. F. and Coe, H. W., contract for *The President* sculpture (August 27, 1925), p. 1, in George Fite Waters Papers (1894–1961) (Houston TX: Joyce Waters Ratliff, 2020).

8 "Lincoln Statue for Portland," *The Boston Herald* (Boston MA: February 6, 1926). The decision to present Lincoln with a beard, at the time he made his ten-sentence speech known as the Gettysburg Address on November 19, 1863, was not supported by any photographic evidence until 1952, when a review of the Still Photo section of the National Archives discovered a glass plate negative for a photograph by Mathew Brady of the speaker's stand at Gettysburg. This was the first photograph that has conclusively identified Lincoln present that day shown sitting in amidst the crowd. Three other photographs possibly show Lincoln leaving Gettysburg on horseback, all of them in the National Archives. The Brady photo shows Lincoln with his distinctive beard.

9 "View Lincoln Statue in French Foundry," *The New York Times* (New York NY: February 12, 1927). The article's mention of "death masks" has mistakenly described the life mask casting of Lincoln in plaster and bronze by the American sculptor Leonard Wells Volk (1860) and a second life mask done by the American sculptor Clark Mills in 1865. There has been wide speculation about a "death mask" made of Lincoln following his assassination, but no conclusive evidence that one was ever made by a sculptor. The article also does not specify where Waters acquired the two masks to use for his modeling of the Lincoln statue in Portland, but they were widely popular as copies made available for purchase through art supply catalogs of the era.

10 "Ceremony Unveils Statue of Lincoln," *op. cit.*, p. 10.

Chapter 6

1 "Skidmore Left a Fountain ... and a Controversy," *The Sunday Oregonian* (Portland OR: November 9, 1941), p. 85.

2 "U. O. Artist Depicts Spirit of Paul Bunyan," *The Maupin Times* (Maupin OR: September 19, 1929), p. 3.

3 "Citizen presents art gift to city," *The Morning Oregonian* (Portland OR: September 4, 1926), p. 1.

4 "South Park Blocks," Portland.gov (2018–2020) (portland.gov/parks/south-park-blocks).

5 Richards, S., "Shemanski Fountain will flow again after renovation," *The Oregonian* (Portland OR: July 18, 1988), p. B-5.

6 Bain, H., "Barrett Sculpture Exhibited," *The Eugene Guard* (Eugene OR: March 1, 1945), p. 12.

7 "Citizen presents art gift to city," *op. cit.*, p. 1.

8 "Shemanski Fountain," Record File PC-29, City of Portland Archives & Records Center (Portland OR: Bureau of Property and Control, February 16, 1968).

9 "U. O. Artist Depicts Spirit of Paul Bunyan," *op. cit.*, p. 3.

10 *Ibid.*

11 "U. of O. Sculptor models mythical hero," *The Athena Press* (Umatilla County OR: July 3, 1931), p. 1.

12 "Federal Arts Project" poster (November 1, 1936) (Washington, D.C.: U.S. Government Printing Office, 1936).

13 "University Art School Praised for Achievement," *The Eugene Register-Guard* (Eugene OR: February 19, 1937), p. 2.

14 "Heroic Statue to Honor Ship," *The Sunday Oregonian*, section 6 (Portland OR: July 17, 1938), p. 1.

15 Federal Writers' Project, *The WPA Guide to Oregon: #33: The Beaver State* (San Antonio TX: Trinity University Press, 2013), p. 138.

16 Perry, D., "What happened to Portland's 'fascist' Theodore Roosevelt Memorial? Mystery remains years later," *OregonianLive.com* (January 10, 2019) (oregonlive.com/life-and-culture/g66l-2019/01/82affb0c708567/what-happened-to-portlands-fas.html).

17 *Ibid.*

Chapter 7

1 McGill, J. S., *The Joy of Effort: A Biography of R. Tait McKenzie* (Oshawa: Clay Publishing Co., 1980), p. 26.

2 *Ibid.*, p. 47.

3 Kozar, A. J., *R. Tair McKenzie: The Sculptor of Athletes* (Knoxville TN: The University of Tennessee Press, 1975), p. 76.

4 Hanaway J. and Cruess R. L., *McGill Medicine: 1885 to 1936* (Montreal QC, Canada: McGill-Queen's University Press, 1996), p. 56.

5 McGill, *op. cit.*, p. 67.

6 Boy Scouts of America, *Boy Scouts Handbook: The First Edition, 1911* (Mineola NY: Dover Publications, Inc., 2005 [reprinted from *The Official Handbook for Boys*, Garden City NY: Doubleday, Page & Company, 1911]), p. v.

7 McKenzie, R. T., "Statue Dedication Speech," (Philadelphia PA: Philadelphia Council Headquarters (BSA), June 12, 1937).

8 McKenzie, R. T., letter to the Chairman, the Commissioner, and the Executive Council of the Boy Scouts of America (March 10, 1911) (scouters.us/TheBoyScout.html).

9 "R. Tait (Robert Tait) McKenzie Papers," [finding aid], University of Pennsylvania, The University Archives and Records Center (archives.upenn.edu/collections/finding-aid/upt50mck37).

10 "The Boy Scout, Two Statues by Dr. Robert Tait McKenzie," Scouters.us (scouters.us/TheBoyScout.html).

11 "Dedication—Columbia Pacific Council—Boy Scouts of America" program (Portland OR: Columbia Pacific Council, March 8, 1972).

Chapter 8

1 Schenk, J., "All the world's a subject for artist," *Toronto Star* (Toronto ON, Canada: April 16, 1985), p. 14.

2 "Block 51: The North Plaza," Voony's Blog (October 26, 2012) (voony.wordpress.com/tag/h-r-savery/#id5).

3 Odam, J., "Courthouse Secret Becomes a Big Fountain of Bubbly," *The Sun* (Vancouver BC, Canada: December 16, 1966), p. 31.

4 Pugh, D. A., letter to Count Alexander von Svoboda (November 24, 1967) (Guelph ON, Canada: Alexander von Svoboda Papers, 2020).

5 Svoboda, A., "The Quest," [sculpture description by artist] (undated) (Guelph ON, Canada: Alexander von Svoboda Papers, 2020).

6 Schenk, *op. cit.*, p. 14.

7 Svoboda, A., *Life Begins Again*, [unpublished book manuscript] (1988) (Guelph ON, Canada: Alexander von Svoboda Papers, 2020), p. 332.

8 *Ibid.*, p. 333.

9 "Georgia Pacific opening stars 17-ton sculpture," *Building Stone News* (New York NY: Building Stone Institute, July 1970).

10 "Perpetuity (sculpture)," Smithsonian American Art Museum (siris-artinventories.si.edu/ipac20/ipac. jsp?&profile=all&source=~!siartinventories&uri=full=3100001~!321034~!0#focus).

11 "The Centennial Fountain at the Vancouver Art Gallery to be removed in the fall," Citynews1130.com (June 26, 2014) (citynews1130.com/2014/06/26/the-centennial-fountain-at-the-vancouver-art-gallery-to-be-removed-in-the-fall/).

Chapter 9

1 Kaskey, R., interview with F. Poyner IV (January 17, 2020).

2 *Ibid*.

3 Kaskey, R., phone interview with F. Poyner IV (August 19, 2020).

4 Kaskey, R., email to F. Poyner IV (August 13, 2020).

5 Forgey, B., "'Portlandia' thrusts sculptor into debate," *The Seattle Times* (Seattle WA: August 21, 1983), p. E-8.

6 *Ibid*.

7 *Ibid*.

8 Kaskey interview (August 19, 2020).

9 "Copper Lady—'Portlandia'—has niche in controversy," *The Seattle Times* (Seattle WA: September 8, 1985), p. B-1.

10 Kaskey interview (January 17, 2020).

11 *Ibid*.

Chapter 10

1 Hansen, J. E., "Notes regarding Equestrian and Guardian series by James Lee Hansen," (August 20, 2020), p. 1.

2 Grafe, S. L., "James Lee Hansen," [exhibition publication] (Goldendale WA: Maryhill Museum of Art, 2014), p. 10.

3 *Ibid*., p. 11.

4 Hansen, J. L., letter to Louis Aaron (Battle Ground WA: James Lee Hansen Archive, August 1959).

5 Hansen, J. L., "Comments on Series Themes, Guardian, Ritual, Equestrian," unpublished manuscript (Battle Ground WA: James Lee Hansen Archive, [undated]).

6 Grafe, op. cit., p. 3.

BIBLIOGRAPHY

Archives

"Abraham Lincoln Statue," Record File PC-29, City of Portland Archives and Records Center (Portland OR: Bureau of Property and Control, March 19, 1968).

"Contract no. 20442: Raymond Kaskey," Record AD/3409, City of Portland Archives & Records Center (Portland OR: City Auditor, December 14, 1985).

"Dedication—Columbia Pacific Council—Boy Scouts of America," [program] (Portland OR: Columbia Pacific Council, March 8, 1972).

"Portland Building / Raymond Kaskey," Record AF/85693, City of Portland Archives & Records Center (Portland OR: Metro Arts Commission [Archival], December 31, 1985).

Proctor, Alexander Phimister, Papers (1892–1980), Mss. 5352, Oregon Historical Society Research Library (Portland OR: Oregon Historical Society).

"Roland Hinton Perry," [bronze purchase order] in *Roman Bronze Works Company ledger #3* (Roman Bronze Works [Archive], 1911), p. 163 (Fort Worth TX: Amon Carter Museum of American Art).

"Roosevelt Statue," Record File PC-29, City of Portland Archives & Records Center (Portland OR: Bureau of Property and Control, October 4, 1967).

"Shemanski Fountain," Record File PC-29, City of Portland Archives & Records Center (Portland OR: Bureau of Property and Control, February 16, 1968).

Snyder, T. A., and Topich, N., "A Guide to the R. Tait (Robert Tait) McKenzie Papers, 1880–1940," [finding aid] Collection no. UPT 50 MCK37, The University Archives and Records Center (Philadelphia PA: University of Pennsylvania, 1992 [2012]).

Svoboda, Alexander von, Papers (1929–2017) (Guelph ON, Canada: Tanya Bull, 2020).

Waters, George Fite, Papers (1894–1961) (Houston TX: Joyce Waters Ratliff, 2020).

Books

Boy Scouts of America, *Boy Scouts Handbook: The First Edition, 1911* (Mineola NY: Dover Publications, Inc., 2005 [reprinted from *The Official Handbook for Boys*, Garden City NY: Doubleday, Page & Company, 1911]).

Buck, D. M., and Palmer, V. A., *Outdoor Sculpture in Milwaukee: A Cultural and Historical Guidebook* (Madison WI: The State Historical Society of Wisconsin, 1995).

Durman, D. C., *He belongs to the ages: the statues of Abraham Lincoln* (Ann Arbor MI: Edwards Bros., 1951).

Federal Writers' Project, *The WPA Guide to Oregon: #33: The Beaver State* (San Antonio TX: Trinity University Press, 2013).

Grissom, C. A., *Zinc Sculpture in America: 1850–1950* (Newark NJ: University of Delaware Press, 2009).

Hanaway, J., and Cruess, R. L., *McGill Medicine: 1885 to 1936* (Montreal QC, Canada: McGill-Queen's University Press, 1996).

Hassrick, P. H., *The best of Proctor's West: an in-depth study of eleven of Proctor's bronzes* (Cody WY: Buffalo Bill Center of the West, 2017).

Jager, R. K., *Malinche, Pocahontas, and Sacagawea: Indian Women as Cultural Intermediaries and National Symbols* (Norman OK: University of Oklahoma Press, 2015).

Kovinick, P. and Yoshiki-Kovinick, M. (eds.), *An Encyclopedia of Women Artists of the American West* (Austin TX: University of Texas Press, 1998).

Kozar, A. J., *R. Tait McKenzie, The Sculptor of Athletes* (Knoxville TN: The University of Tennessee Press, 1975).

Leys, J. F., *Robert Tait McKenzie and The Mill of Kintail* (Ottawa, 1955).

McGill, J. S., *The Joy of Effort: A Biography of R. Tait McKenzie* (Oshawa: Clay Publishing Co., 1980).

Proctor, A. P., *Sculptor in Buckskin; an autobiography* (Norman OK: University of Oklahoma Press, 1971).

Reed, H. H. and Cole, J. Y. (eds.), *The Library of Congress: Its Construction, Architecture, and Decoration* (New York NY: W. W. Norton & Company, 1997).

Snyder, E., *Portland's Potpourri: Art, Fountains & Old Friends* (Portland OR: Binford & Mort, Publishing, 1991).

United States Department of the Treasury, *Public works of art project, Report of the assistant secretary of the Treasury to federal emergency relief administrator, December 8, 1933–June 30, 1934* (Washington, D.C.: United States Government Printing Office, 1934).

Periodicals and Newspapers

Bain, H., "Barrett Sculpture Exhibited," *The Eugene Guard*, p. 12 (Eugene OR: March 1, 1945).

Beers, C., "Rose and Shine Down in Portland," *The Seattle Times*, p. C-2 (Seattle WA: May 17, 1986).

Dworkin, A., "Footsteps lead from fountains…," *The Oregonian*, p. S-16 (Portland OR: December 16, 2007).

Evans, S. A., "Club Work of Oregon Women," *The Oregon Daily Journal*, p. 16 (Portland OR: December 25, 1904).

Forgey, B., "'Portlandia' thrusts sculptor into debate," *The Seattle Times*, p. E-8 (Seattle WA: August 21, 1983).

Gleason, N. C., "The Portland Public Art Tradition," *The Sunday Oregonian*, p. 130 (Portland OR: January 23, 1983).

Grafe, S. L., "James Lee Hansen," [exhibition publication] (Goldendale WA: Maryhill Museum of Art, 2014).

Odam, J., "Courthouse Secret Becomes a Big Fountain of Bubbly," *The Sun*, p. 31 (Vancouver BC, Canada: December 16, 1966).

Reed, B., "Quirky and Proud of It," *The Philadelphia Inquirer* [travel section], p. F-14 (Philadelphia PA: November 21, 2010).

Richards, S., "Shemanski Fountain will flow again after renovation," *The Oregonian*, p. B-5 (Portland OR: July 18, 1988).

Schenk, J., "All the world's a subject for artist," *The Toronto Star*, p. 14 (Toronto ON, Canada: April 16, 1985).

Struthers, R., "Famous sculptor re-emerges from obscurity," *East Oregon* (Pendleton OR: September 8, 2017).

Terry, J., "Statue features a strain of elk peculiar to Portland's history," *The Oregonian*, p. B-4 (Portland OR: November 1, 1998).

Thompson, D., [letter to City of Portland] in "Gives a Fountain," *The Oregonian*, p. 8 (Portland OR: June 7, 1899).

"A good historical novel," *Oregon Daily Journal*, p. 10 (Portland OR: June 9, 1916).

"An Ornamental Bronze Foundry," *The Foundry*, Volume 31, Number 5, pp. 202-206 (Cleveland OH: Penton Publishing Company, January 1908).

"Battleship Oregon Park Seeks Skidmore Fountain," *The Oregonian*, p. 1 (Portland OR: September 30, 1941).

"Bigger than Life, Shiny Guardian Gravely Graces Portland Building," *The Seattle Times*, p. B-2 (Seattle WA: October 13, 1985).

"Ceremony Unveils Statue of Lincoln," *The Morning Oregonian*, p. 10 (Portland OR: October 6, 1928).

"Citizen presents art gift to city," *The Morning Oregonian*, p. 1 (Portland OR: September 4, 1926).

"City News in Brief-Elk for the Fountain," *The Morning Oregonian*, p. 7 (Portland OR: July 31, 1900).

"City News in Brief," *The Morning Oregonian*, p. 5 (Portland OR: August 20, 1900).

"City News in Brief-Fountain Elk in Position," *The Morning Oregonian*, p. 7 (Portland OR: August 27, 1900).

"Copper Lady – 'Portlandia' – has niche in controversy," *The Seattle Times*, p. B-1 (Seattle WA: September 8, 1985).

"D.P. Thompson's Gift to Portland," *The Morning Oregonian*, p. 23 (Portland OR: January 1, 1900).

"Dr. W.H. Coe Returns," *The Morning Oregonian*, p. 4 (Portland OR: September 23, 1920).

"Elks' Rest – Imposing Dedication Ceremony Yesterday at Woodmere," *The Detroit Free Press*, p. 5 (Detroit MI: October 31, 1892).

"The Elks' Reunion," *The Courier Journal*, p. 8. (Louisville KY: April 24, 1891).

"Georgia Pacific opening stars 17-ton sculpture," *Building Stone News* (New York NY: Building Stone Institute, July 1970).

"Getting into his work," *El Paso Herald-Post* (El Paso TX: July 6, 1970).

"Gives a Fountain," *The Oregonian*, p. 8 (Portland OR: June 7, 1899).

"Hail, Portlandia," *The Seattle Times*, p. B-2 (Seattle WA: October 7, 1985).

"Hero and his Horse will see unveiling," *Seattle Daily Times*, p. 23 (Seattle WA: April 25, 1913).

"Heroic Statue to Honor Ship," *The Sunday Oregonian* [section 6], p. 47 (Portland OR: July 17, 1938).

"His Bust in Clay," *The Seattle Daily Times* [pictorial section], p. 4 (Seattle WA: February 22, 1925).

"Idea to Move Icon Upsets Artist," *The Seattle Times*, p. B-2 (Seattle WA: February 19, 1998).

"Joan of Arc may now be Canonized," *Oregon daily journal*, p. 4 (Portland OR: April 28, 1918).

"Lincoln Statue a gift," *Kansas City Star* (Kansas City MO: February 7, 1926).

"Lincoln Statue for Portland," *The Boston Herald* (Boston MA: February 6, 1926).

"Michael Muller wins first prize for oil painting," *Seattle Daily Times*, p. 11 (Seattle WA: October 1, 1930).

"Oliver Laurence Barrett," *The Eugene Guard*, p. 3 (Eugene OR: August 9, 1943).

"Oliver L. Barrett dies at Age 50," *The Bend Bulletin*, p. 6 (Bend OR: August 11, 1932).

"Portlanders chipping in to Rescue City Sculpture," *The Seattle Times*, p. A-8 (Seattle WA: January 20, 1985).

"Rise and Progress of the Art of Sculpture in America," *Seattle Daily Times*, p. 14 (Seattle WA: April 18, 1904).

"The Sacajawea Monument," *Daily East Oregonian*, p. 4 (Pendleton OR: October 25, 1904).

"Seal of the City," *The Morning Oregonian*, p. 3 (Portland OR: March 22, 1878).

"Skidmore Left a Fountain . . . and a Controversy," *The Sunday Oregonian*, p. 85 (Portland OR: November 9, 1941).

"Statue by proctor is Declared to be virile record of Theodore Roosevelt," *The Sunday Oregonian*, p. 13 (Portland OR: November 12, 1922).

"Statue is Picturesque," *The Morning Oregonian*, p. 8 (Portland OR: November 4, 1922).

"Statue to be Unveiled," *The Morning Oregonian*, p. 24 (Portland OR: October 2, 1928).

"This is Elks' Day," *The Morning Oregonian*, p. 8 (Portland OR: September 6, 1900).

"U. O. Artist Depicts Spirit of Paul Bunyan," *The Maupin Times*, p. 3 (Maupin OR: September 19, 1929).

"U. of O. Sculptor models mythical hero," *The Athena Press*, p. 1 (Umatilla County, OR: July 3, 1931).

"University Art School Praised for Achievement," *The Eugene Register-Guard*, p. 2 (Eugene OR: February 19, 1937).

"View Lincoln Statue in French Foundry," *The New York Times* (New York NY: February 12, 1927).

"What can be seen around Portland," *The Oregon Daily Journal*, p. 7 (Portland OR: August 12, 1915).

[Notice about Shemanski Family and Portland Menorah Society], *The Morning Oregonian*, p. 10 (Portland OR: May 24, 1922).

Unpublished Material, Personal Communications, and Internet Sources

Appelbaum, Y., "Take the Statues Down," *The Atlantic* (August 13, 2017) (theatlantic.com/politics/archive/2017/08/take-the-statues-down/536727/).

Boehme, S. E., "Alexander Phimister Proctor and Gertrude Vanderbilt Whitney: Sculptor in Buckskin and American Princess," Center of the West.org (centerofthewest.org/2016/04/17/points-west-proctor-and-whitney/).

Bull, T., email to F. Poyner IV, re. Alex Svoboda (June 15, 2020).

Bull, T., email to F. Poyner IV, re. sculpture *The Quest* (June 19, 2020).

Dimick, J., email to F. Poyner IV, re. Elks' Rest sculpture at Woodmere Cemetery (June 5, 2020).

Gray, C., "Streetscapes – Readers' Questions: A Charmer that was ahead of its time," *The New York Times* (July 30, 2009) (nytimes.com/2009/08/02/realestate/02scapes.html).

Grissom, C. A., "Cemetery Monuments made of Zinc," Smithsonian Museum Conservation Institute (si.edu/mci/english/research/conservation/zinc_cemetery_monuments.html).

Grutchfield, W., "J. W. Fiske Ironworks," Walter Grutchfield.net (2012) (waltergrutchfield.net/fiske.htm).

Hansen, J. L., "Comments on Series Themes, Guardian, Ritual, Equestrian," unpublished manuscript (Battle Ground WA: James Lee Hansen Archive [undated]).

Hansen, J. L., "Interview question replies for Fred Poyner IV," (July 20, 2020).

Hansen, J. E., phone call with F. Poyner IV (August 19, 2020).

Hansen, J. E., "Notes regarding *Equestrian* and *Guardian* series by James Lee Hansen," (August 20, 2020).

Hassrick, P., "On the War Path," Center of the West.org (June 10, 2017) (centerofthewest.org/2017/06/10/on-the-war-path/).

Johnson, J. S., interview with F. Poyner IV (February 25, 2020).

Kaskey, R., interview with F. Poyner IV (January 17, 2020).

Kaskey, R., email to F. Poyner IV (August 13, 2020).

Kaskey, R., phone call with F. Poyner IV (August 19, 2020).

Libby, B., "The Elk statue is just fine," Portland Architecture – a blog about design in the rose city (August 24, 2020) (chatterbox.typepad.com/portlandarchitecture/2020/08/the-elk-statue-is-just-fine.html).

Lewis, D. G., "Alexander Phimister Proctor in Oregon," NDN History Research (September 2, 2017) (ndnhistoryresearch.com/2017/09/02/alexander-phimister-proctor-in-oregon/).

McKenzie, R. T., letter to the Chairman, the Commissioner, and the Executive Council of the Boy Scouts of America (March 10, 1911) (scouters.us/TheBoyScout.html).

McKenzie, R. T., "Statue Dedication Speech," (Philadelphia PA: Philadelphia Council Headquarters (BSA), June 12, 1937).

Newkirk, L. E., "Fountain Unveiling heralds major corporate art collection," [Georgia-Pacific press release] (June 18, 1970) in Alexander von Svoboda Papers (Guelph ON, Canada: Tanya Bull, 2020).

Parkinson, H., "Rare photo of Lincoln at Gettysburg," National Archives Pieces of History (November 19, 2010) (prologue.blogs.archives.gov/2010/11/19/rare-photo-of-lincoln-at-gettysburg/).

Perry, D., "What happened to Portland's 'fascist' Theodore Roosevelt Memorial? Mystery remains years later," *OregonianLive.com* (January 10, 2019) (oregonlive.com/life-and-culture/g66l-2019/01/82affb0c708567/what-happened-to-portlands-fas.html).

Pletz, E., email to F. Poyner IV, re. *Exalted Ruler* sculpture by Rip Caswell (May 4, 2020).

Pugh, D. A., letter to Count Alexander von Svoboda (November 24, 1967) (Guelph ON, Canada: Alexander von Svoboda Papers, 2020).

Smithsonian American Art Museum (SAAM) Online Collections (2020) (americanart.si.edu/art).

Srinath, S., "The Joans of Frémiet," Saving Antiquities.org (May 29, 2017) (savingantiquities.org/curious-case-twin-joans/).

Svoboda, A., *Life Begins Again*, [unpublished book manuscript] (1988) (Guelph ON, Canada: Alexander von Svoboda Papers, 2020).

Svoboda, A., "A Lifetime of Art Work by Alex von Svoboda (1929-1974)," [timeline of events] (Guelph ON, Canada: Alexander von Svoboda Papers, 2020).

Svoboda, A., "The Quest," [sculpture description by artist] (undated) (Guelph ON, Canada: Alexander von Svoboda Papers, 2020).

Waters, G. F., and Coe, H. W., contract for *The President* sculpture (August 27, 1925), George Fite Waters Papers (1894-1961) (Houston TX: Joyce Waters Ratliff, 2020).

Wilson, E., "Object Spotlight: Proctor's Rough Rider," Center of the West.org (March 28, 2014) (centerofthewest.org/2014/03/28/object-spotlight-alexander-phimister-proctors-rough-rider/).

"A4 Quest," PDXccentric.com, URL: (pdxccentric.wordpress.com/a4-quest/).

"Americana Week in New York," *Found.com* (January 24, 2016) (foundantiquesde.com/blog/americana-week-in-new-york).

"Annals of the Order: 'ONCE AN ELK, ETERNALLY AN ELK'," Elks.org (elks.org/who/history/cemetery.cfm).

"Block 51: The North Plaza," Voony's Blog (October 26, 2012) (voony.wordpress.com/tag/h-r-savery/#id5).

"The Boy Scout – Two Statues by Dr. Robert Tait McKenzie," Scouters.us (scouters.us/TheBoyScout.html).

"The Centennial Fountain at the Vancouver Art Gallery to be removed in the fall," Citynews1130.com (June 26, 2014) (citynews1130.com/2014/06/26/the-centennial-fountain-at-the-vancouver-art-gallery-to-be-removed-in-the-fall/).

"Chapman Square," Portland Parks and Recreation, City of Portland (2020) (portlandoregon.gov/parks/finder/index.cfm?action=ViewPark&PropertyID=99).

"Dallas' Removed Robert E. Lee Sculpture Transferred to New Owner," NBCDFW.com (June 27, 2019) (nbcdfw.com/news/local/dallas-removed-robert-e-lee-sculpture-transferred-to-new-owner/214562/).

"Dedication – Columbia Pacific Council – Boy Scouts of America," [program] (Portland OR: Columbia Pacific Council, March 8, 1972).

"Elks' Rest (sculpture)," record no. IAS MI000059, Smithsonian American Art Museum Arts Inventories Catalog (siris-artinventories.si.edu/ipac20/ipac.

jsp?session=1C002A77324R0.314&profile=ariall&source=~!siartinventories&
view=subscriptionsummary&uri=full=3100001~!319059~!19&ri=1&aspect=
Keyword&menu=search&ipp=20&spp=20&staffonly=&term=roland+perry&index=.
GW&uindex=&aspect=Keyword&menu=search&ri=1).

"Federal Arts Project," [poster] (November 1, 1936) (Washington, D.C.: U.S. Government Printing Office, 1936).

"Henry Waldo Coe (1857–1927)," Mandan Historical Society (mandanhistory.org/biographiesak/henrycoe.html).

"Important Americana – lot 1575 / Catalogue Note – American Elk," Sotheby's e-catalogue (2016) (sothebys.com/en/auctions/ecatalogue/2016/important-americana-n09456/lot.1575.html).

"Joan of Arc (1890)," Association for Public Art [Philadelphia PA] (associationforpublicart.org/artwork/joan-of-arc/#).

"New Deal Fairy Tale, Nursery Rhyme, and Story Art (7/10): Paul Bunyan and Babe the Blue Ox," New Deal of the Day (June 14, 2017) (nddaily.blogspot.com/2017/06/new-deal-fairy-tale-nursery-rhyme-and_14.html).

"Oregon Visual Arts Ecology Project," [Alice Cooper statue] Oregon Visual Arts.org (oregonvisualarts.org/portfolio-items/alice-cooper-racc-historic-portland-sculpture-1/).

"Oregon Visual Arts Ecology Project," [Emmanuel Frémiet statue] Oregon Visual Arts.org (oregonvisualarts.org/portfolio-items/emmanuel-frmiet-racc-historic-portland-sculpture-3/).

"Past Auction: J. W. Fiske (American)," *Artnet.com* (artnet.com/artists/j-w-fiske/american-elk-WJF0pDfdOMs8q5_WouPWpg2).

"Perpetuity (sculpture)," Smithsonian American Art Museum (siris-artinventories.si.edu/ipac20/ipac.jsp?&profile=all&source=~!siartinventories&uri=full=3100001~!321034~!0#focus).

"Proctor Monumental Sculptures," Alexander Phimister Proctor Foundation (aphimisterproctorfoundation.com/sculptures/proctor-monumental-public-sculptures/).

"R. Tait McKenzie," Smithsonian American Art Museum (americanart.si.edu/artist/r-tait-mckenzie-3233).

"R. Tait (Robert Tait) McKenzie Papers," [finding aid] University of Pennsylvania, The University Archives & Records Center (archives.upenn.edu/collections/finding-aid/upt50mck37).

"Robert Tait McKenzie, 1867-1938," Scouters.us (scouters.us/RTaitMcKenzie.html).

"Sculptor Gutzon Borglum," nps.gov (nps.gov/moru/learn/historyculture/upload/sculptor%20gutzon%20borglum%20a.pdf).

"Sculpture, Paul Bunyan," [online catalog entry] Jordan Schnitzer Museum of Art (jsmacollection.uoregon.edu/mwebcgi/mweb?request=record;id=15951;type=101).

"South Park Blocks," Portland.gov (2018–2020) (portland.gov/parks/south-park-blocks).

"Zinc Sculpture," Smithsonian Museum Conservation Institute (si.edu/mci/english/research/conservation/zinc_sculptures.html).

INDEX